MYTH & MAGIC

HarperCollins*Publishers*
77-85 Fulham Palace Road,
Hammersmith, London W6 8JB

www.tolkien.co.uk

Published by HarperCollins*Publishers* 2001
4

MYTH & MAGIC

THE ART OF JOHN HOWE

HarperCollins*Publishers*

ACKNOWLEDGEMENTS

DEDICATION

This book is for my two families - the one in which I grew up and the one that has grown up around me:

For my parents Rosena Dorothy and William Kelly Howe, who treated my scribblings with indulgence and pride.

For my big brother William J who put up with my scribblings, and taught me how to ride a bike and light campfires.

For my fellow illustrator and wife Fataneh and our son Dana, who put up with my scribblings too, and who reassure me that they're not bad, except for that little bit there that could do with a...

THANKS

This list deserves pages and pages, from childhood friends to illustrious colleagues, all of whom have brought their warmth and wisdom to my palette. For used paperback hunts and high-school antics, long hikes and art-school aspirations, first books, steep learning curves, brief encounters in other centuries, and all those conversations that start with 'Have you seen this picture by...?'

SPECIAL THANKS:

To Jane, who published my first Tolkien illustration; to Alan, Alison, Tamlyn and Val of Arena who have brought me their discipline and friendship; to Gerry, the Companie of Saynt George and friends; to Arnaud, Bernard, Etienne, Francine, Gail, John, Nicole and Stella for the children's books; to Peter and Fran, who invited us to Middle-earth for a long visit; to Megan, Robert, Anne, Claude and Charles, who wrote the words before (and after) the pictures, and to Brian, Sir Ian, and Peter, who found the words in them; to Claudine and Gérard; to Robert, for the fun and games; to Chris and David, who made sense of my ramblings and brought some order to it all; and to Alan Lee, who I *know* has been to Avalon and Hy Brazil.

Celtic Myth
Fantasy Art of the New Millennium,
HarperCollins 1999

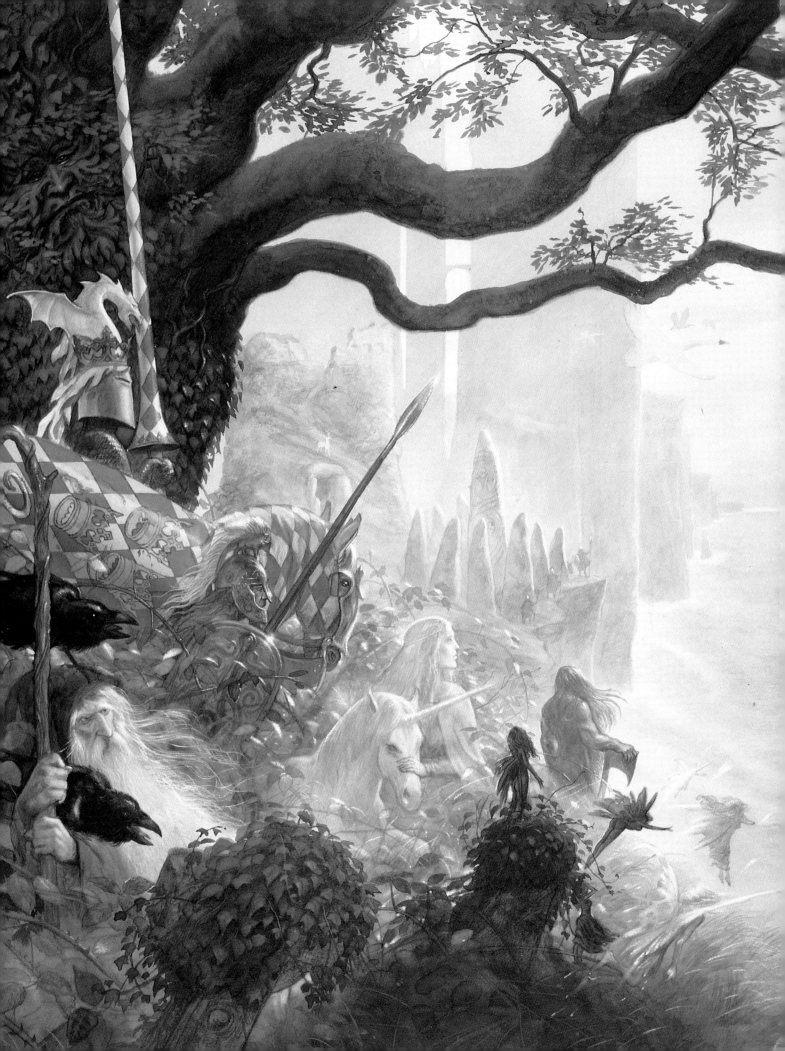

MYTH &

CONTENTS

MAGIC

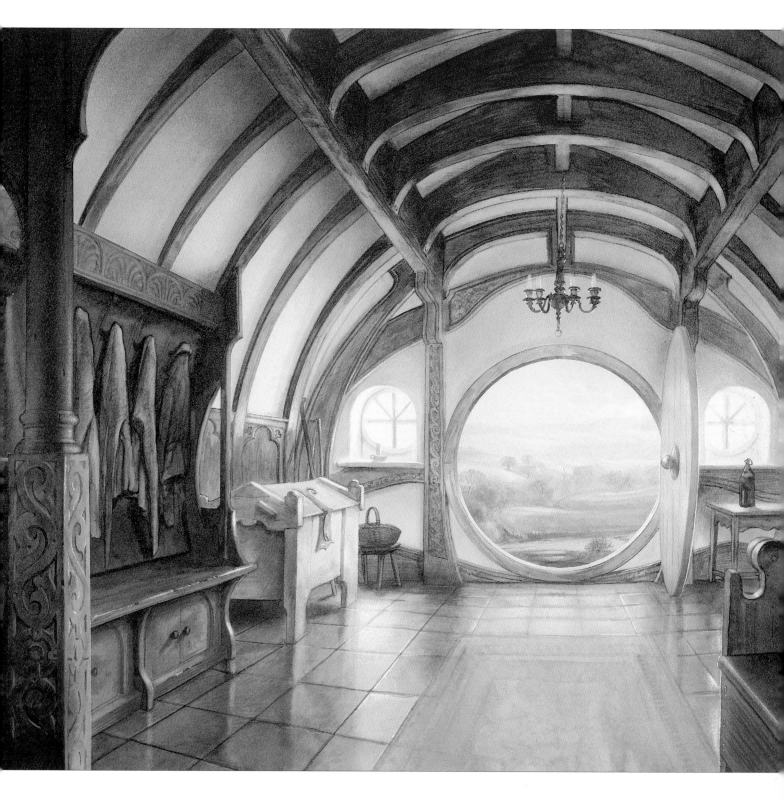

FOREWORD

I was a fan of John Howe's work long before I met him.

Back in 1995, when Fran Walsh and myself were first thinking about making a film adaptation of *The Lord of the Rings*, we were inspired by John's paintings in the 1991 Tolkien calendar. 'Sam and Shelob', 'Éowyn and the Nazgûl' and 'At the Ford' all seemed like still images from a movie. Many of his paintings have that quality – capturing a frozen moment of high drama. They also have a reality to them – a sense of fantasy as history. They got us very excited about the visual possibilities that a film could offer.

I discovered that there was no single collection of John's artwork, so we went on a 'John Howe hunt', trying to find every picture he'd done. It was tough, as they were scattered on dozens of book covers and calendars. The internet, second-hand bookshops and Tolkien societies were mined for any artwork by John. We'd buy a book if it had just one new painting. Eventually we used John's artwork in presentations, trying to interest Hollywood in the idea of a Tolkien movie – and it worked because we

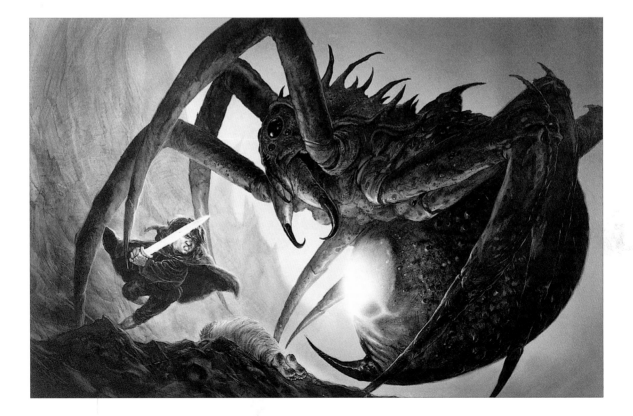

got the money. Without his knowledge, he was already playing an important role in bringing *The Lord of the Rings* to cinematic life.

Sometime in 1997 I plucked up the courage to call John and ask him to work on the movies. I was a big fan by this time, and was nervous at the thought of speaking with him – but luckily I found him to be very gracious, with a wonderfully dry sense of humour. And that call resulted in John and his lovely family spending over 18 months in New Zealand. I'd always loved John's paintings of Gandalf, and when I finally met him in person, I realized that he *is* Gandalf, literally – those paintings are self portraits of John with another 30 years added on!

Working alongside Alan Lee as a conceptual artist and designer, John would come to work every day, sharpen his pencil and draw. Thousands of designs were produced, covering all the events and characters from *The Lord of the Rings*.

It was a lot of fun. I'd always loved John's painting of the Bag End hallway, which I thought captured the perfect Hobbit hole. However, it was frustrating - for years I'd been staring at the picture wondering what the rest of Bag End looked like. I was now able to get him to draw it for me! Conversely, I realized that John had never painted Minas Morgul, so I asked him for his vision of the lair of the Witch-king – it was pretty amazing and went straight into the movie.

John's artistic influence went beyond buildings and castles. His painting of Gandalf striding through the rain is the greatest illustration of Tolkien's wizard I've ever seen – the tramp-like clothing and hawk-like gaze capture an intensity that goes way beyond the cliché of a pointy-hatted wizard. I naturally wanted our movie Gandalf to look exactly like that, which resulted in Sir Ian McKellen having to endure hours of make-up and wardrobe tests, with me waving John's picture around saying 'The hat's not right yet – it has to look like this!'

John's visual style has translated strongly on screen. In our movie version of *The Fellowship of the Ring*, it's John's Gandalf that arrives at John's Bag End. Gandalf delights the Hobbits with John's fireworks whilst, many miles away, John's Barad-dûr rises again above the Mordor landscape. And the movie Balrog that Sir Ian McKellen confronts in Moria is a first cousin to the beast you will see in these pages.

A definitive collection of John Howe's artwork in one volume is the book I dreamt of all those years ago… that one day I would be writing an introduction to such a book is more than a dream come true.

Peter Jackson
Wellington, NZ

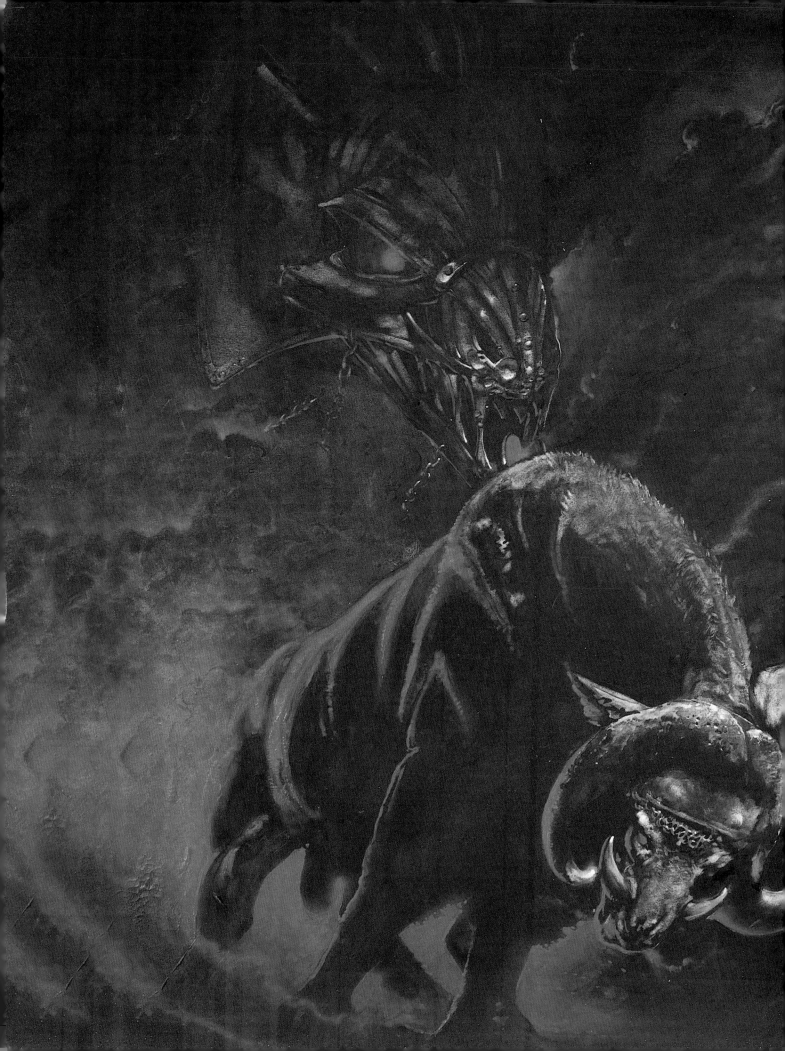

CHAPTER ONE

FORMATIONS

On the living room wall there was a pencil rendering of the Castle of Chillon, near Lake Geneva, done by my grandmother at age 19, before she embraced the more acceptable career of schoolmistress and never did another picture in her life...

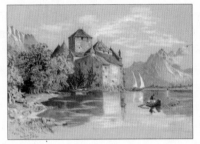

I can't remember ever not drawing. My mother would do her best to help with the more ambitious renderings, but around primary school age, her draughtsmanship was no longer up to my expectations. I remember bursting into tears of frustration when we both failed to draw a cow the way I wanted.

School itself was a mixed blessing; it seemed we always moved house at just the wrong time of the year, and I ended up in power mechanics, hating every

minute, because naturally, all the non-academics too dull even for metal shop were already parked in art class… It was a handy skill in biology, though, where a friend and I would do rapid and rather creative rendering of microscopic water organisms for richer but less artistic classmates… at 50 cents a shot.

I collected paperbacks for the covers, and even read what was inside. Frank Frazetta assumed demigod status, and was the object of dozens of copies in oil pastel. This was before the Ballantine editions, so his paintings were only available on book covers. No musty second-hand paperback pile went unturned. Around the same time, Barry Smith's *Conan* and Berni Wrightson's *Swamp Thing* meant going into drugstores where I wouldn't run into anyone I knew, buying kid's comics too far into adolescence.

Around that time I read *The Lord of the Rings*, first *The Two Towers*, and then *The Return of the King.* It seemed that everyone who started the first volume never got any further, as it was by far the most-borrowed of the three. I had to wait

Previous: Grond
unpublished
1979

Left: Cigarette Pinnochio
L'Illustré 1984

Knight on airplane wing
unpublished 1980

months to get it. The real spark came from the calendars, which showed me that it *could* be illustrated. I went through the Hildebrandt calendar, doing my own versions of the same scenes. Mercifully, none of these have survived, although there is a very dusty box under a bed somewhere…

A year after graduating from high school, I was in a college in Strasbourg, France, and the following year in the Ecole des Arts Décoratifs. The first year was spent not understanding much, the second at odds with what I did manage to understand, and the third eager to get out, although in retrospect I certainly owe whatever clarity of thought I possess to the patience of the professor of Illustration.

Otherwise, my first years in Europe were a constant overdose on all forms of art and

Opposite: Gandalf & the Balrog
unpublished 1979

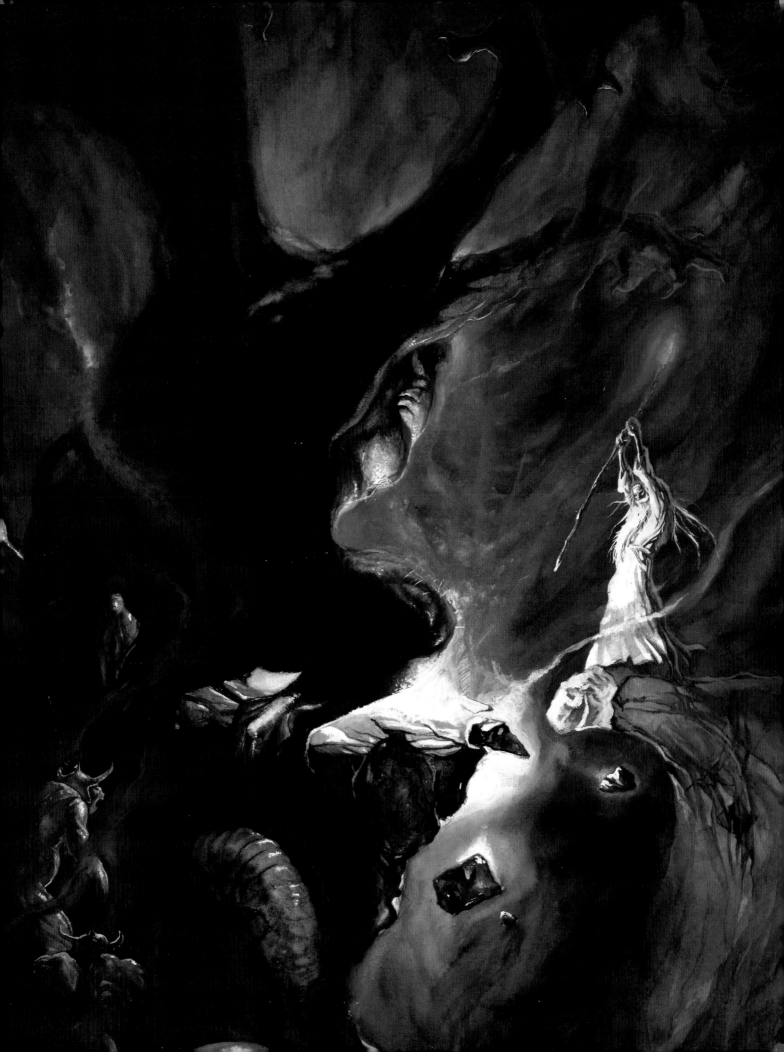

architecture, everything being simultaneously ancient and novel. All that catching up to do. Nothing I did from those years has survived, thank goodness, as I scrupulously put it all in the trash at term end before heading back home to the summer job that would pay next year's fees. The only exception must be 'The Lieutenant of the Black Tower of Barad-dûr' [page 132], which, if not my first published piece, must certainly be the earliest.

It seems to me that a lot of my early commissions were nightmares – political cartoons, magazine illustrations, comics, animated films, advertising – starting one cover seven times, redoing sketches so many times there was nothing of mine left in them, wondering just how the devil I'd ended up in this profession. In

Above: LotR logo
Student project 1979

Above: Jade logo
Jade, Precious and Wild CD 1991

Below: Man on Yak
unpublished 1981

Left: La Navire Spatiale (The Space Ship) Exhibition catalogue, "Il Était un petit navire", La Joie de Lire 1986

Below: The Road to Dunwich
unpublished 1982

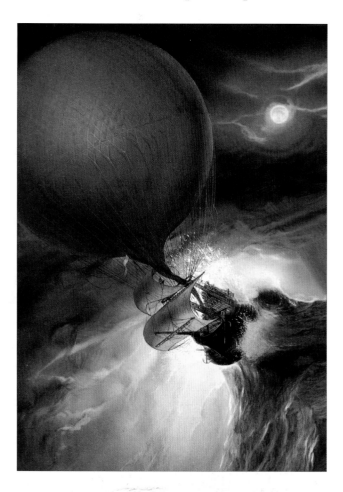

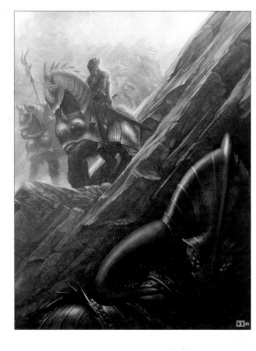

Left: Raymondin & Melusine
unpublished 1982

Right: Chevaliers
unpublished 1982

Below: The Isle of Apples
unpublished 1984

the attic there is a huge box taped very tightly shut and marked DO NOT OPEN (EVER!!!) in wide-tip felt pen. I honestly feel no real urge to do so.

The other day we took a friend to visit the Castle of Chillon. It's easy enough to find the spot to stand in my grandmother's drawing. I wonder if we ever really make any choices of our own - so many years and miles to end up in a picture that was always there on the wall.

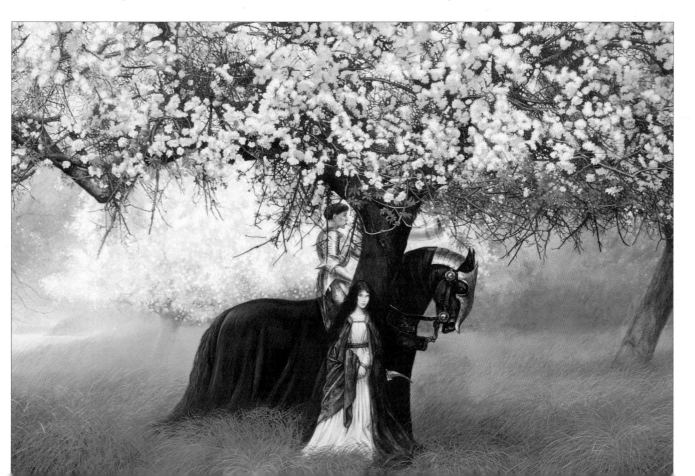

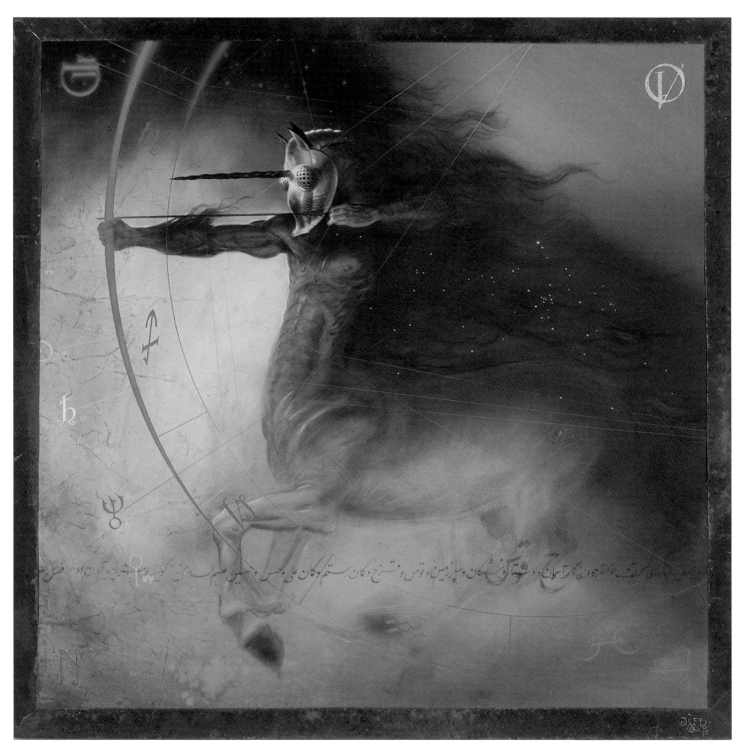

Sagittarius: Dana Howe
unpublished 1995

Grendel, The Enchanted World Series
Time-Life Books 1996

SKULL STILL LIFE

Of course, that skull wasn't just laying there on the rocky outcrop waiting to be painted… but I did put it back again, I promise! My student obsession with skulls and bones has never really diminished. Once over the most obvious symbolism and initial reluctance, bones of all creatures have the most incredibly aesthetic shapes. The art school had a collection worthy of a natural history museum. They still crop up in my work occasionally: 'The Dark Tower', for example, [page 122] is built on an assemblage of bird skulls belonging to a classmate.

Skull still life
unpublished 1980

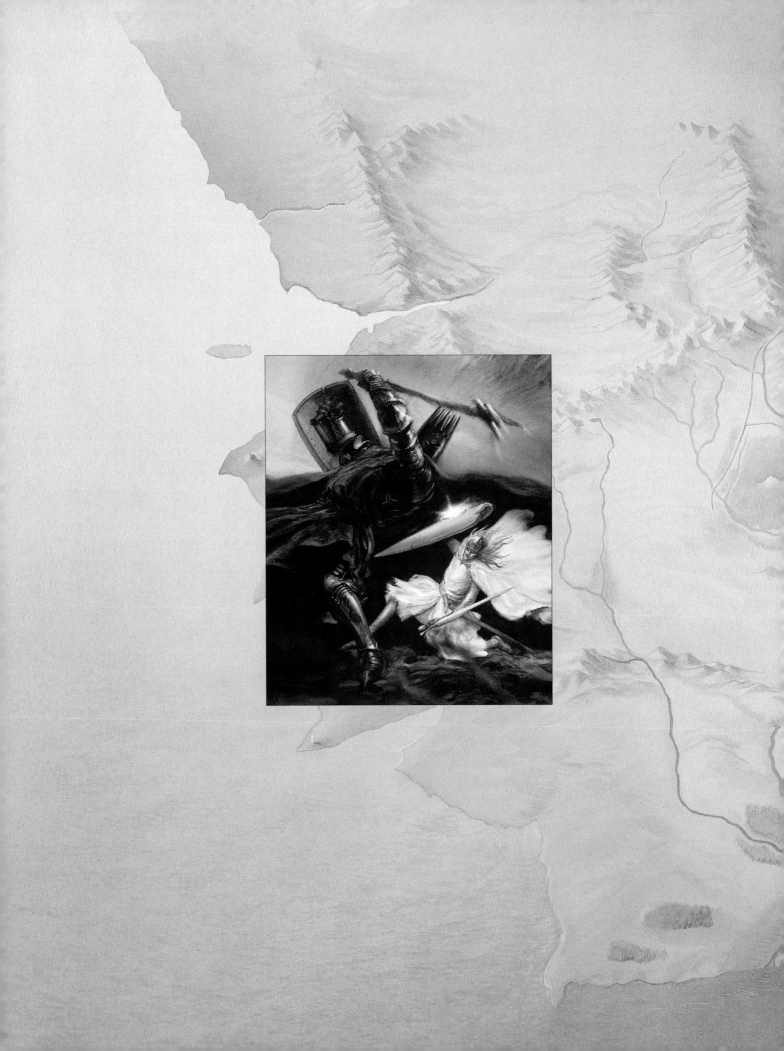

Chapter Two

The Painting of Middle-earth

A wrap-around book cover only leaves the bottom two-thirds of the right-hand half free for illustrating – about one quarter of the entire format – as all the rest is occupied by title, author, spine and back cover copy. It is therefore very hard to work the picture up as a whole and not neglect those parts destined to be covered. However, just filling them in with smears of colour is totally unsatisfying. Such is the lot of anyone who plans to illustrate book covers! My favourite of all the covers that I have painted to illustrate the First and Second-Age Tolkien work is 'Attack on Gondolin'[pages 24/25], the cover of *The Map of Beleriand*, where all of Morgoth's creatures – Balrogs and Dragons – are dark on black, and totally obscured by text. If

I have the time, I most enjoy working extra hard on the parts of the paint-ing that will not appear on the front of the cover.

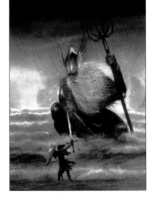

Opposite: The Fall of Gondolin
The Silmarillion by J R R Tolkien edited
by Christopher Tolkien, Grafton 1990

Overleaf:
Ulmo, The Lord of Waters
Unfinished Tales by J R R Tolkien edited
by Christopher Tolkien, Grafton 1991

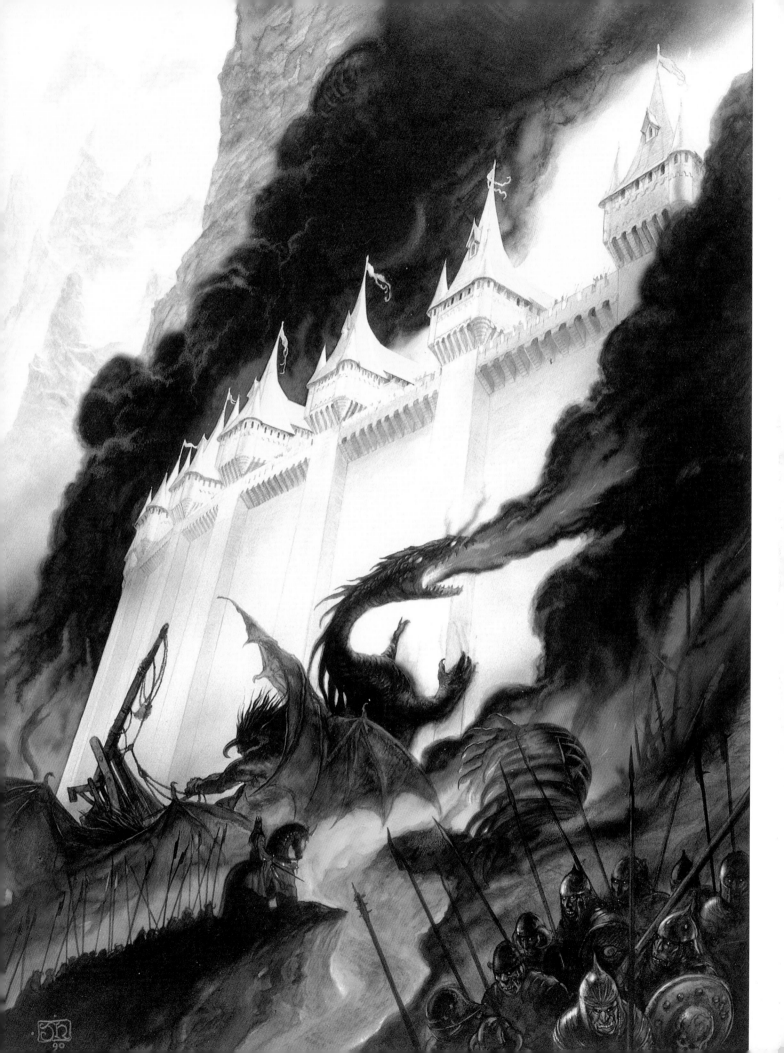

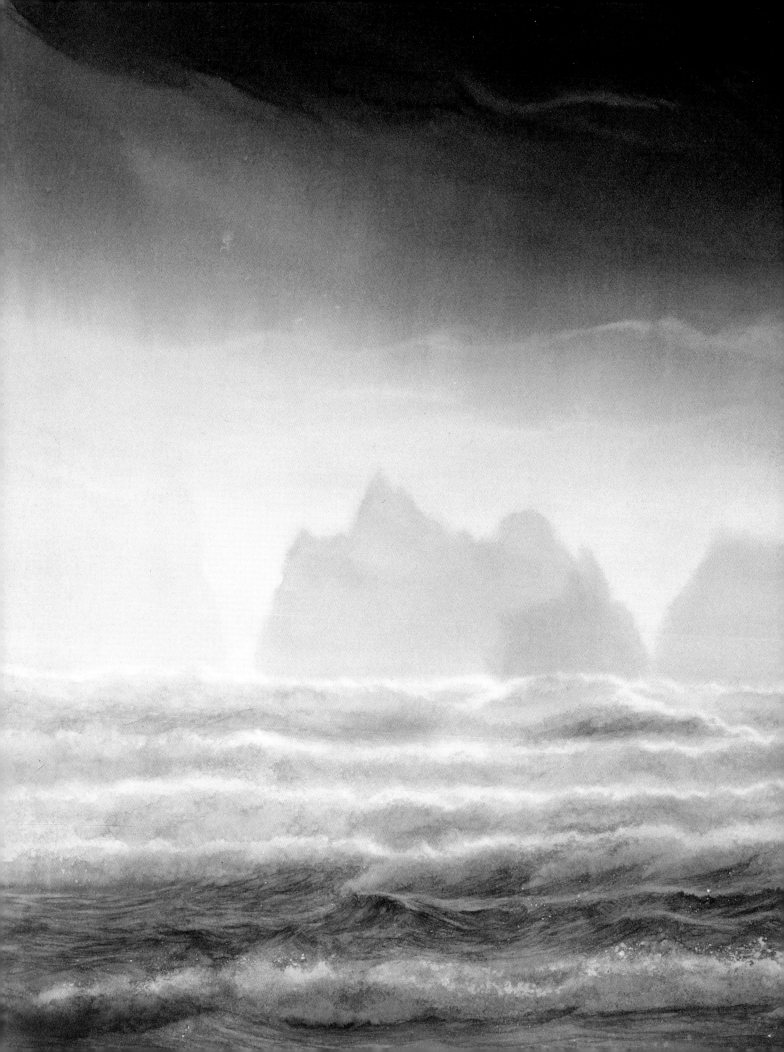

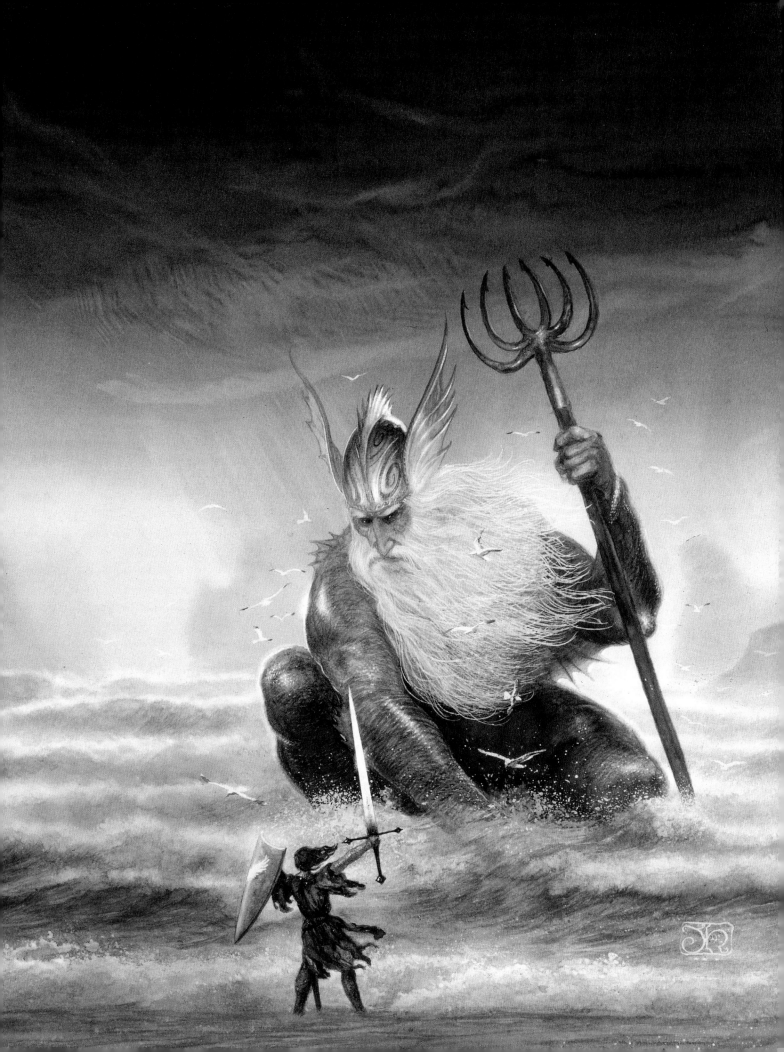

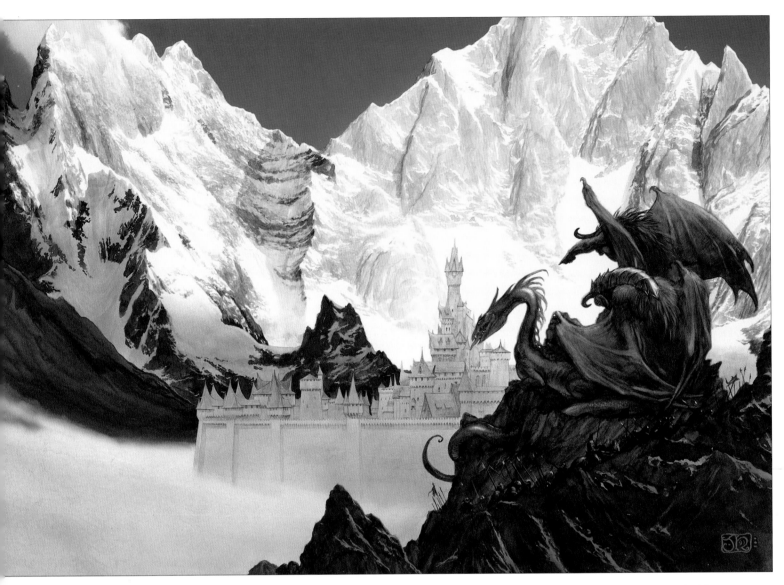

The Battle for Gondolin
The Book of Lost Tales, Part One
by J R R Tolkien edited by
Christopher Tolkien, Grafton 1991

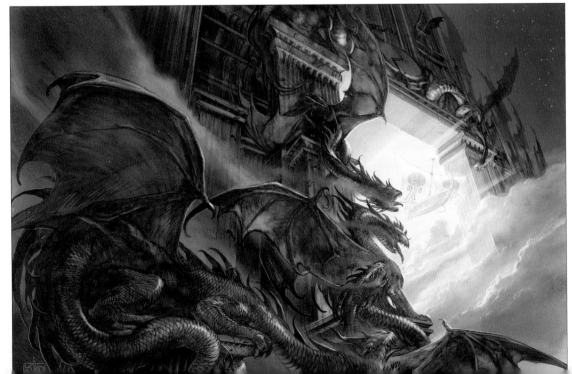

The Doors of Night
The Book of Lost Tales, Part Two
by J R R Tolkien edited by
Christopher Tolkien, Grafton 1992

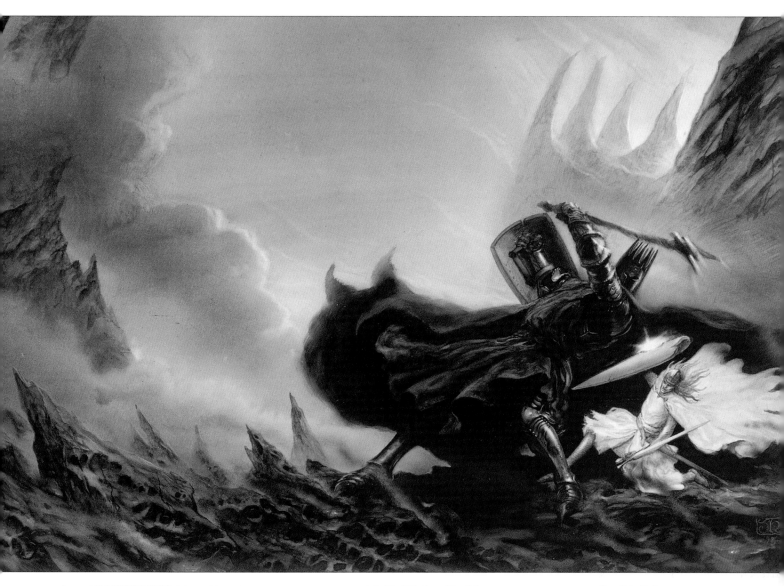

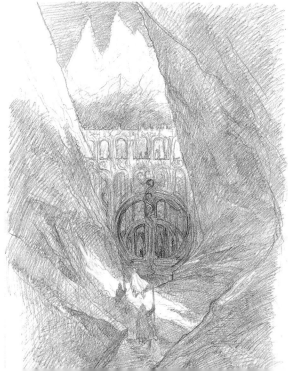

Left: The Fifth Gate of Gondolin
(sketch) unpublished 2000

Fingolfin's Challenge
The Lays of Beleriand by J R R Tolkien
edited by Christopher Tolkien, Grafton 1992

Edhellond
Iron Crown Enterprises 1997

The White Towers
Iron Crown Enterprises 1997

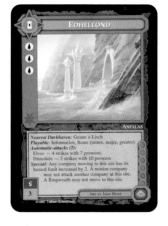

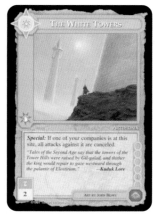

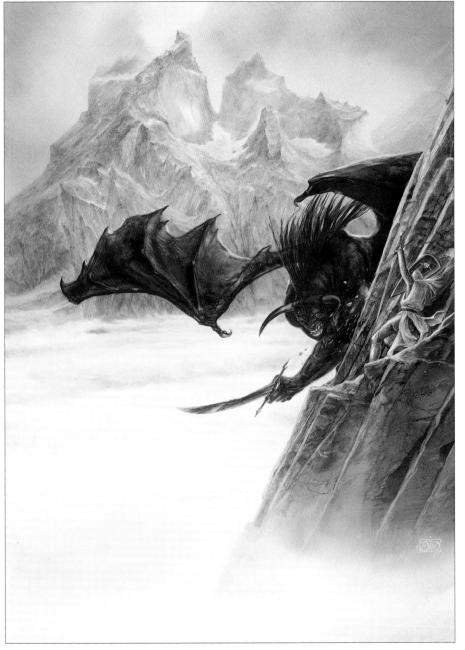

Above: Glorfindel & the Balrog
Tolkien Calendar 1991
1989

Below: The Siege of Angband
The Shaping of Middle-earth by J R R Tolkien
edited by Christopher Tolkien, Grafton 1993

Below: Angband
The Map of Tolkien's Beleriand by
Brian Sibley, HarperCollins 1999

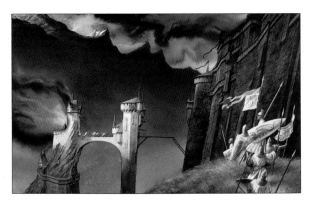

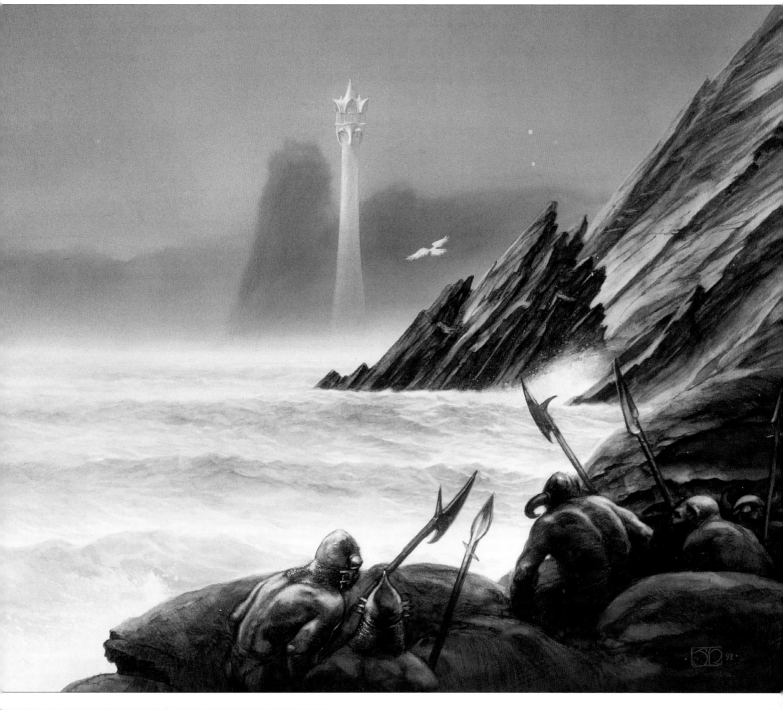

Above: The White Tower of Elwing
The Lost Road by J R R Tolkien edited
by Christopher Tolkien, Grafton 1993

Overleaf: Attack on Gondolin
The Map of Tolkien's Beleriand by
Brian Sibley, HarperCollins 1999

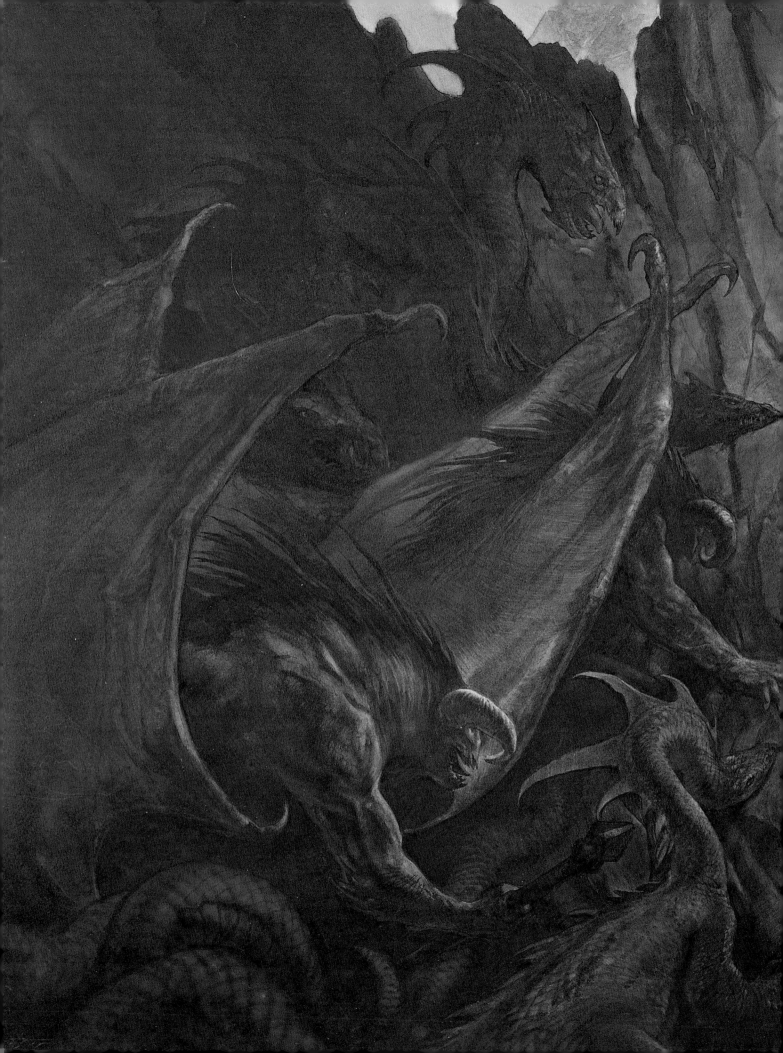

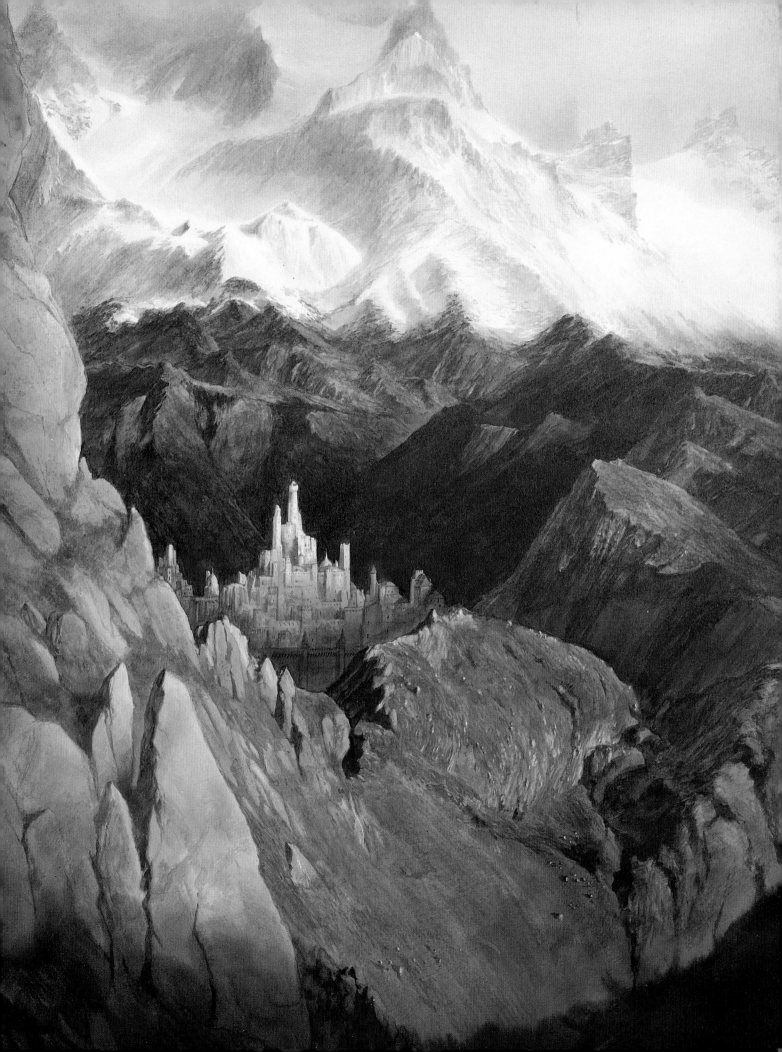

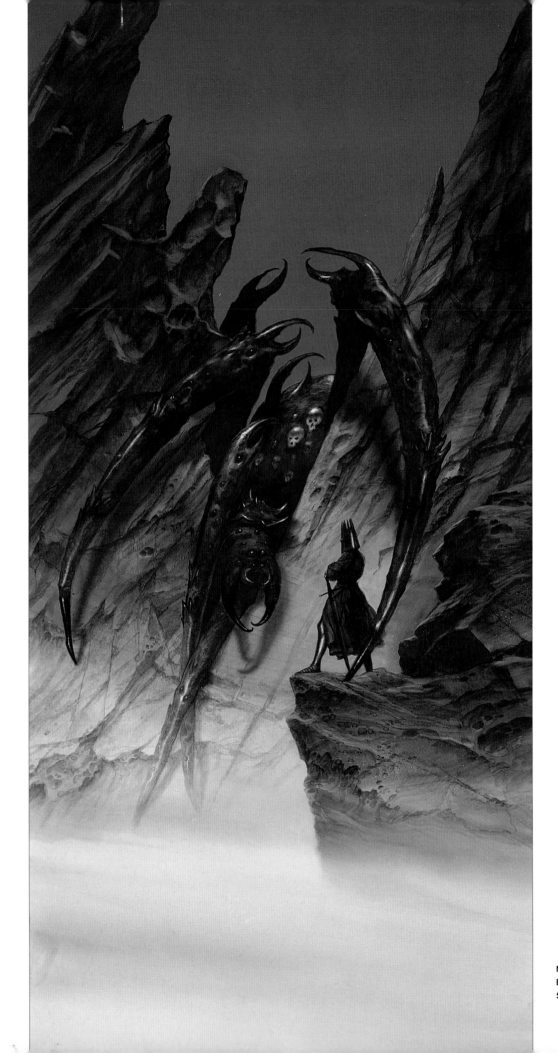

Melkor Calls forth Ungoliante
Exhibition poster, Médiatheque de
Saint-Herblain 1996

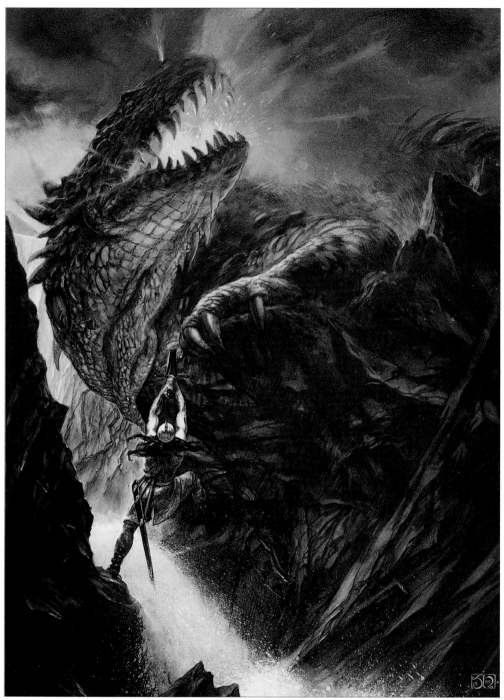

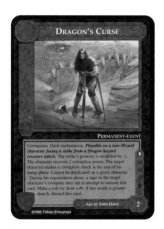

DRAGON'S CURSE

PERMANENT-EVENT

Above: Dragon's Curse
Iron Crown Enterprises
1997

Left: Turambar and Glorund
Tolkien Calendar 1991
1989

Below: The Sea The Map of Tolkien's
Beleriand by Brian Sibley,
HarperCollins 1999

Overleaf: The Drowning of Anadûnê
Sauron Defeated by Christopher
Tolkien, HarperCollins 1993

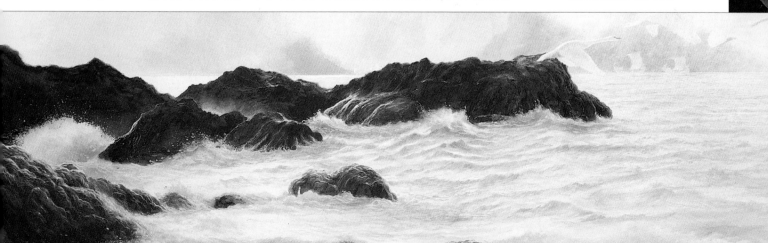

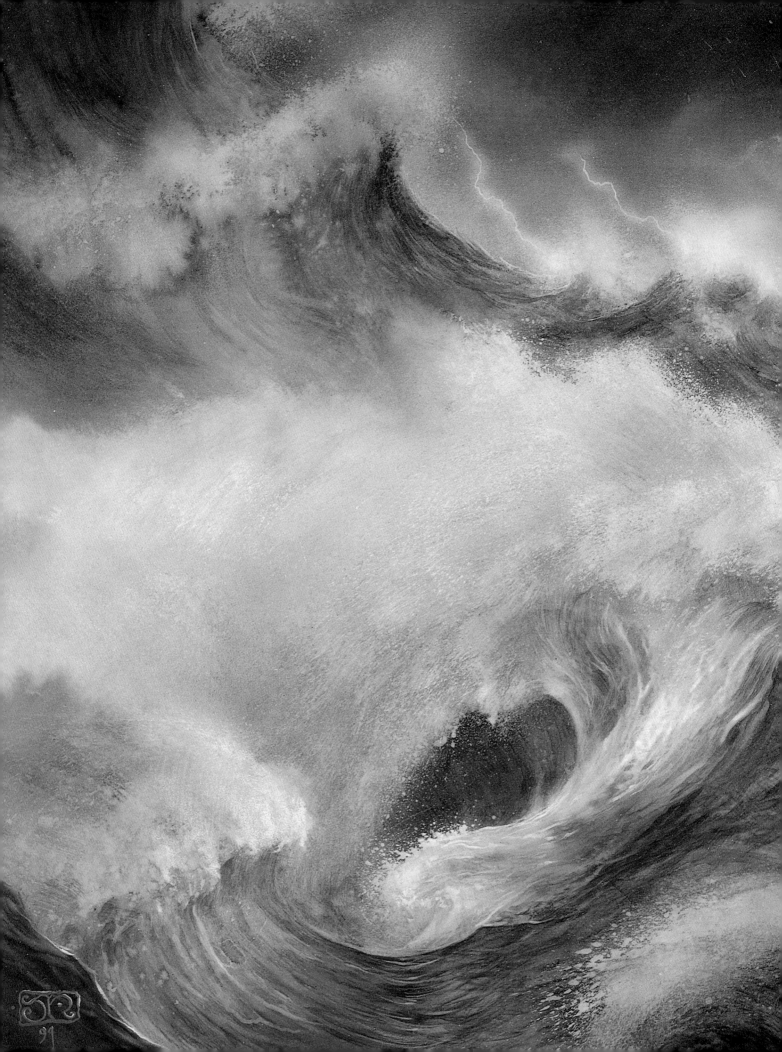

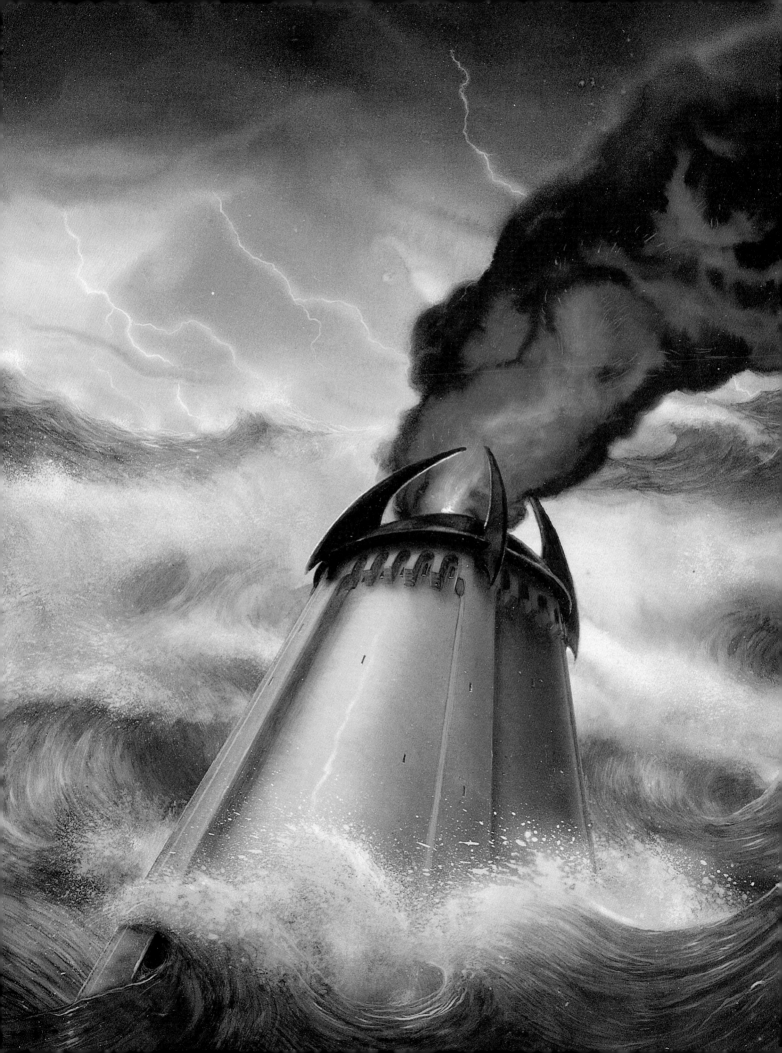

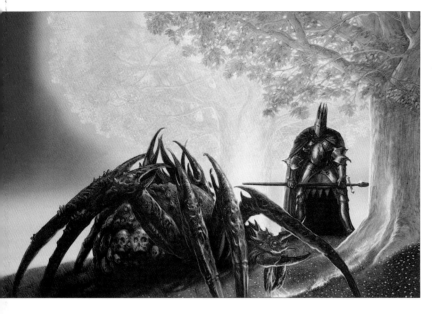

The Killing of the Trees
Morgoth's Ring by Christopher
Tolkien, HarperCollins 1994

Nienor and Glaurung
The War of the Jewels by Christopher
Tolkien, HarperCollins 1995

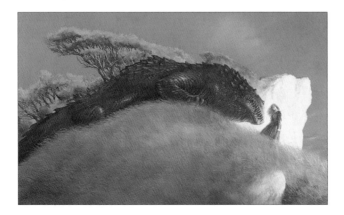

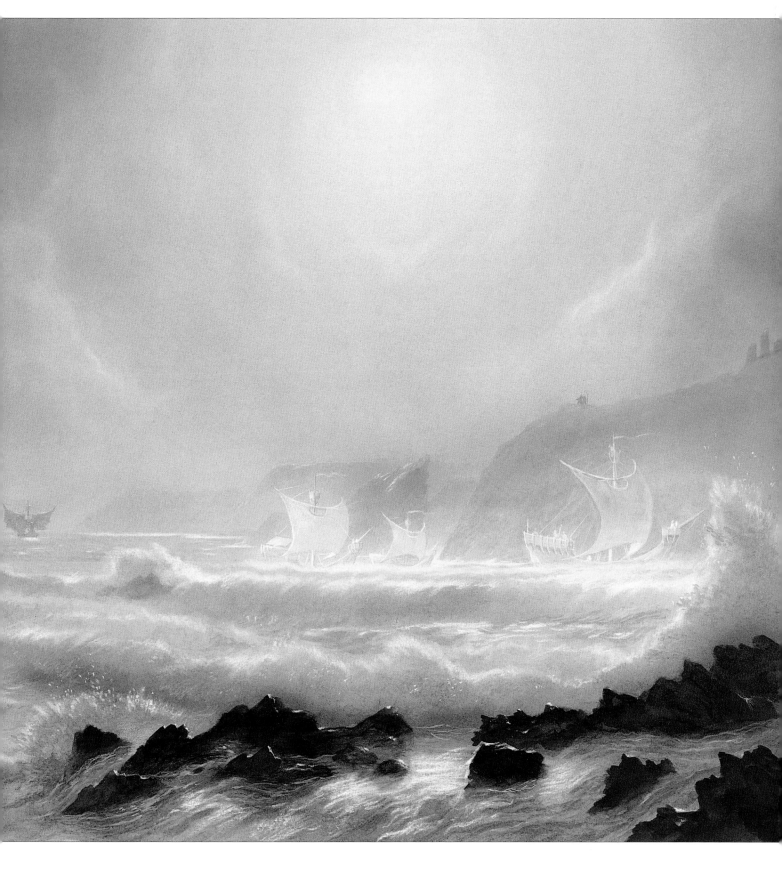

The Ship of the Dark
The Peoples of Middle-earth by
Christopher Tolkien, HarperCollins 1997

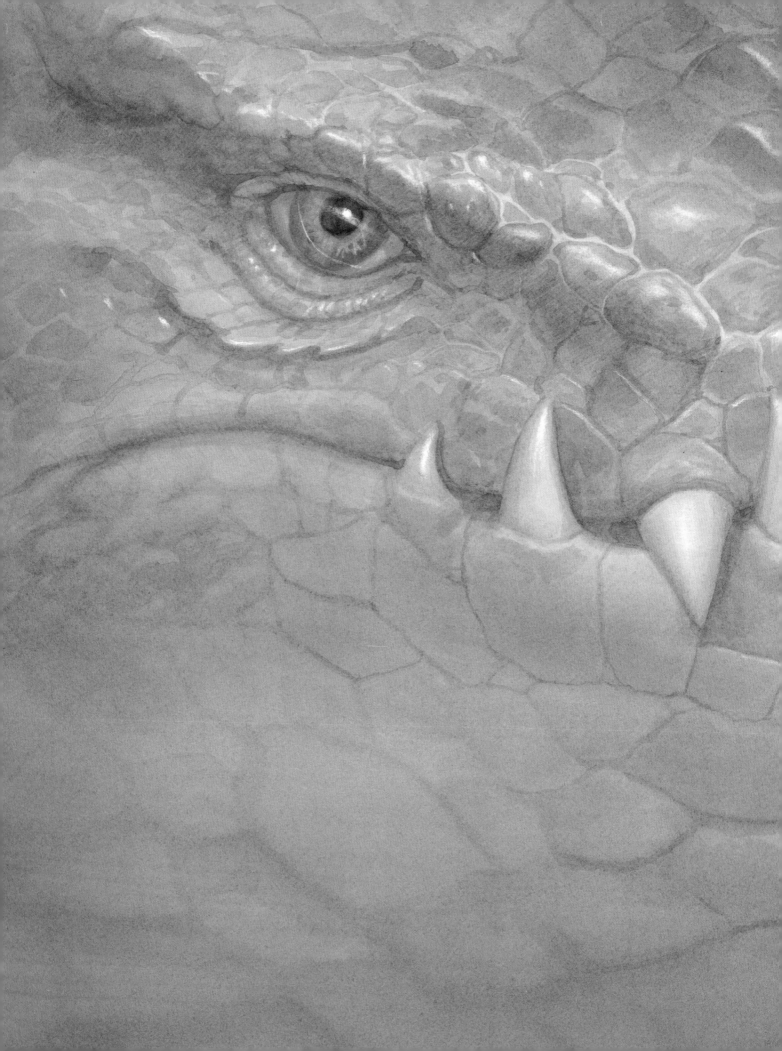

MYTH & MAGIC

CATHEDRALE

In Strasbourg, there is a cathedral, and somehow I ended up with a paper giving me temporary possession of a pass key, which let me through all the locked doors of the whole edifice. I spent countless afternoons in a world of red sandstone; it was magical. I climbed to the top of the spire – 140 metres of emptiness all around. I sat out thunderstorms under ranks of spouting gargoyles, and even spent one night in a sleeping bag, cold, miserable and exhilarated waking up every hour with the bells just underneath. All dreadfully romantic, but that's what art students are supposed to do, gather up little scraps of wonder

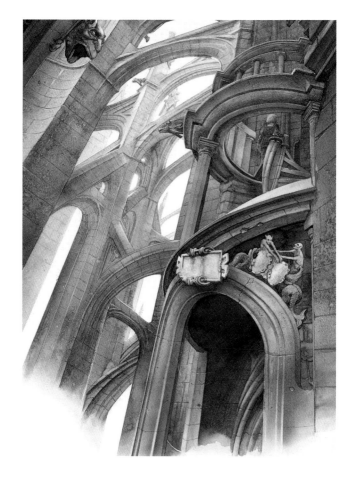

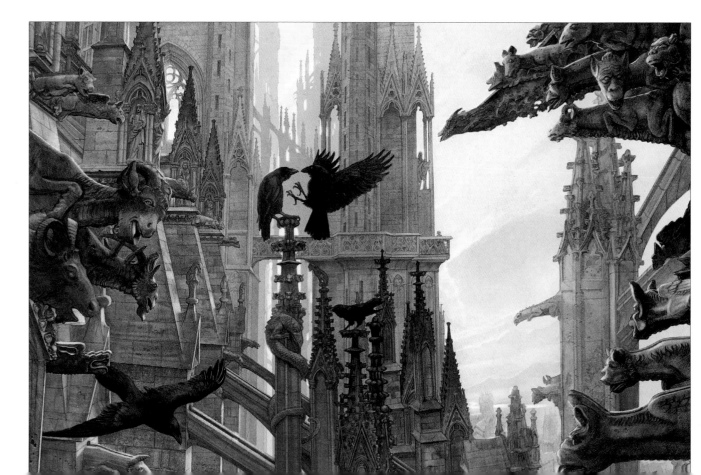

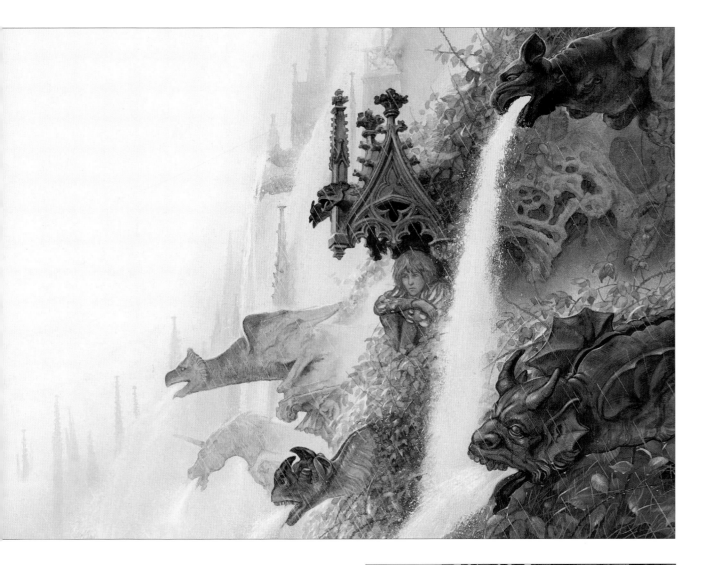

wherever they are to be found. This serendipitous first-hand encounter with high gothic architecture led to *Cathedrale*.

The story is about a boy who decides suddenly, very early one morning, to climb the cathedral that dominates his town and has been there for so long that no adult really notices it any more. Of course, it's a world up there, peopled by a multitude of sandstone creatures and unlikely encounters. I suppose the story is a parable, a quest *and* a fairy tale… but mostly a good excuse to indulge in a craving for gothic architecture.

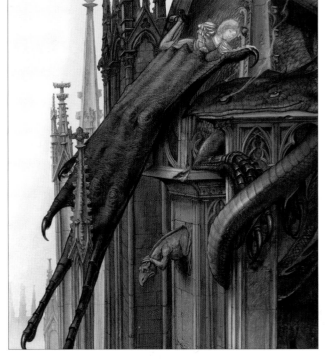

Cathedrale by John Howe,
Bueb & Reumaux 1994

JACK AND THE BEANSTALK

I've always felt a little sorry for the giant in this story. After all, he is only minding his own business when Jack sneaks in and becomes a popular hero first by stealing everything the giant owns, and then luring him to his death!

Of course, a children's book is no place to explore *that* side of the story, so I had fun with the costume and the landscape – one of my recurring bad dreams involves steep grassy slopes that grow steeper and steeper until I fall right off or wake up. The giant's realm is something from out of this dream, framed by nothing except the kind of clouds you see from an airplane.

**Jack and the Beanstalk by
John Howe, Anansi 1989**

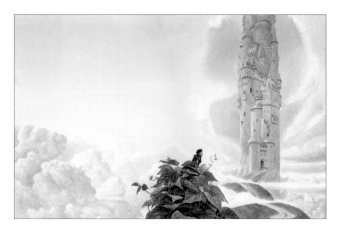

**Below: Rip van Winkle, by Washington Irving retold
by John Howe, Little Brown and Company (US) 1988**

RIP VAN WINKLE

I remember panicking over Rip Van Winkle, trying desperately to find any kind of documents on pumpkins, of all things. The typical orange Hallowe'en pumpkin was practically unknown in Switzerland at the time; I searched three libraries and all the bookshops and *kiosques* in town in vain, covetously casing out garden plots to no avail. Luckily the editor came to my rescue!

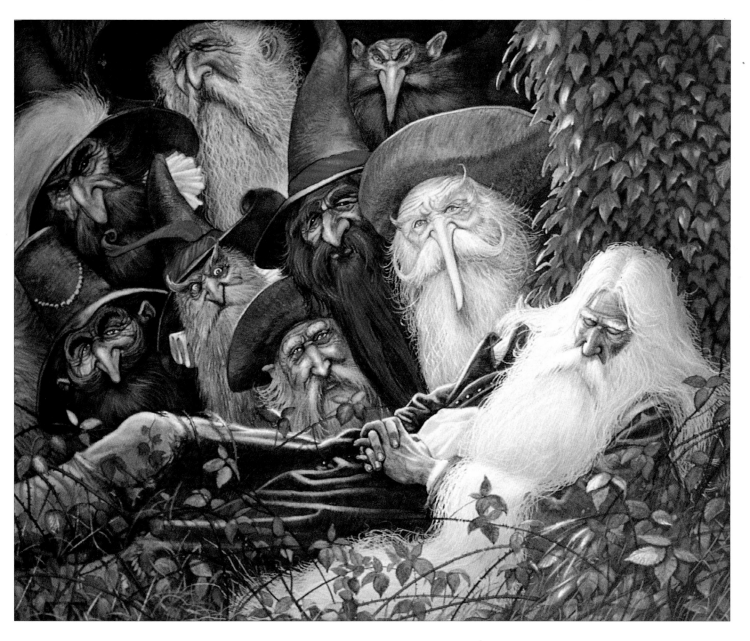

ARMOUR

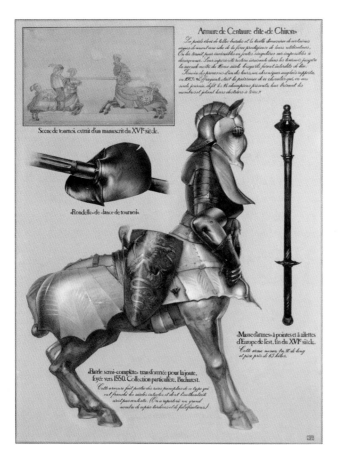

Above: Armure de Centaure, dite de Chiron
unpublished 1983

My fascination with armour was initially purely visual – like just about anything else with which I am infatuated. (I would have ravens, horseshoe crabs, rhinoceroses and manta rays for pets if I could.) The shapes themselves of these metallic exoskeletons are incredibly complex and beautiful. All the lines and forms, without exception, are full of energy and purpose. Historical armour is difficult to understand, fabulous to wear, nearly impossible to draw. This handful of pictures is all that remains of the ambitious beginnings of a whole series of suits drawn from animal shapes and mythological beings. I had even started on a coherent universe for them to wander about bashing each other in. Perhaps one day...

(rhino armour 1)
unpublished 1983

Armure de Centaure,
dite de Chiron 2
unpublished 1983

(rhino armour 2)
unpublished 1983

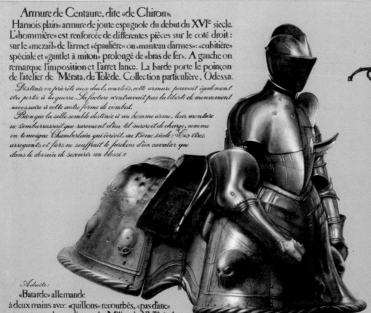

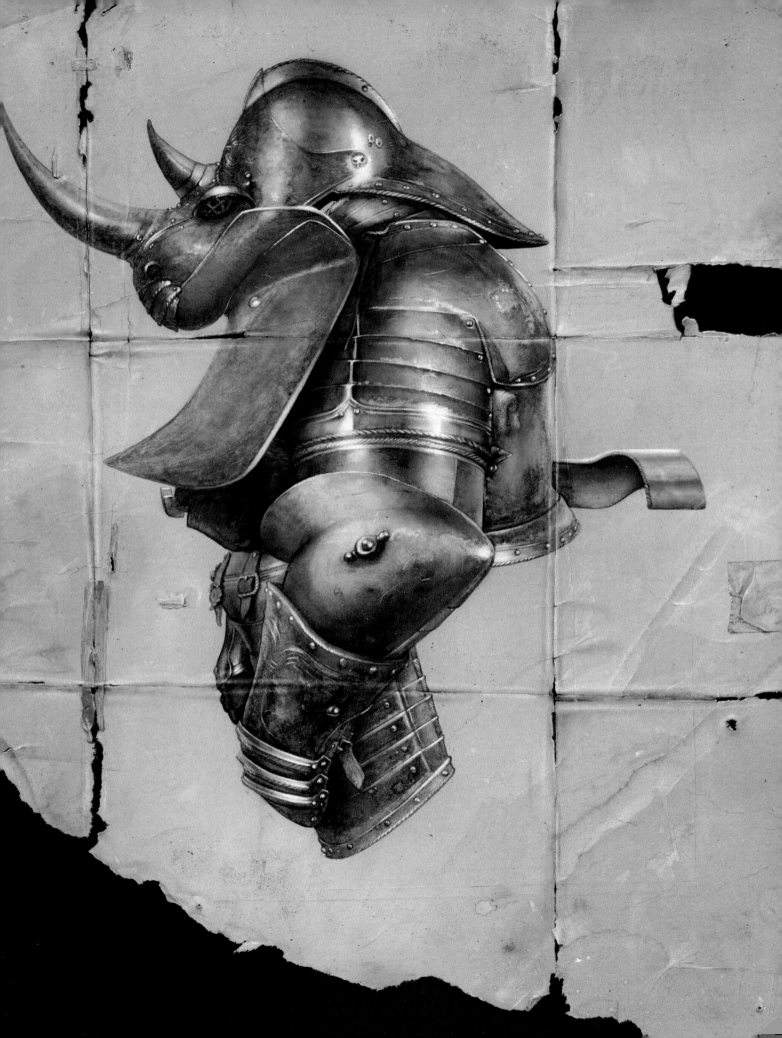

L'HOMME QUI ALLUMAIT LES ETOILES

The Man who Lit the Stars was originally a comic written and illustrated by me about outcasts from a cruel society who find in their exclusion a new horizon. It was published by Métal Hurlant in the 1980s. I'd always felt that the treatment of it was lacking, and asked Claude if she would be willing to transform it into a children's story. She added a character and a rather more hopeful ending than the rather grim, inconclusive one that I had done.

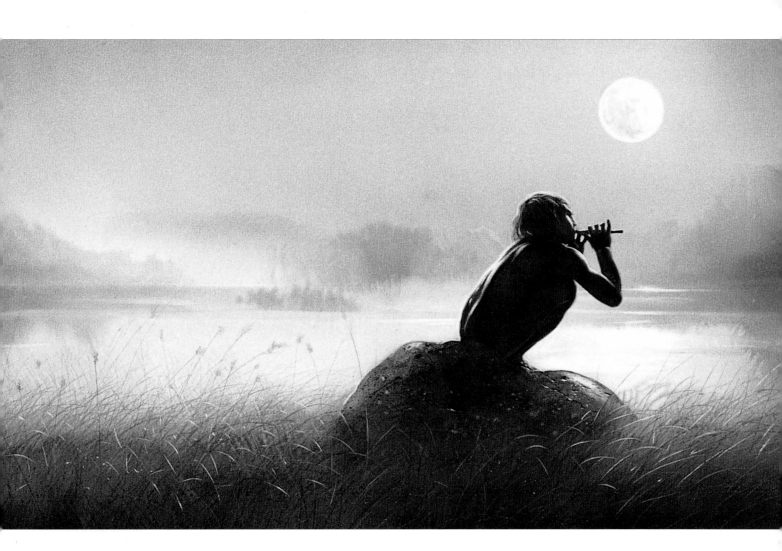

LE MUSICIEN DE L'OMBRE

Claude Clément is a children's author who lives in Paris. All her stories are deeply symbolic, and are always understated. While she describes atmosphere and mood with intense precision, none of it rests on easily defined detail. The Musician from the Shadows is about the birth of music, but a music for solitude, a response to man's fear of the darkness and exclusion. The flute is the symbol of the musician's acceptance of those fears, and becomes the metaphor for man's self-realisation.

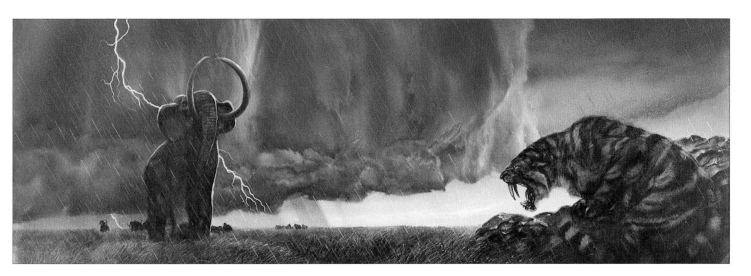

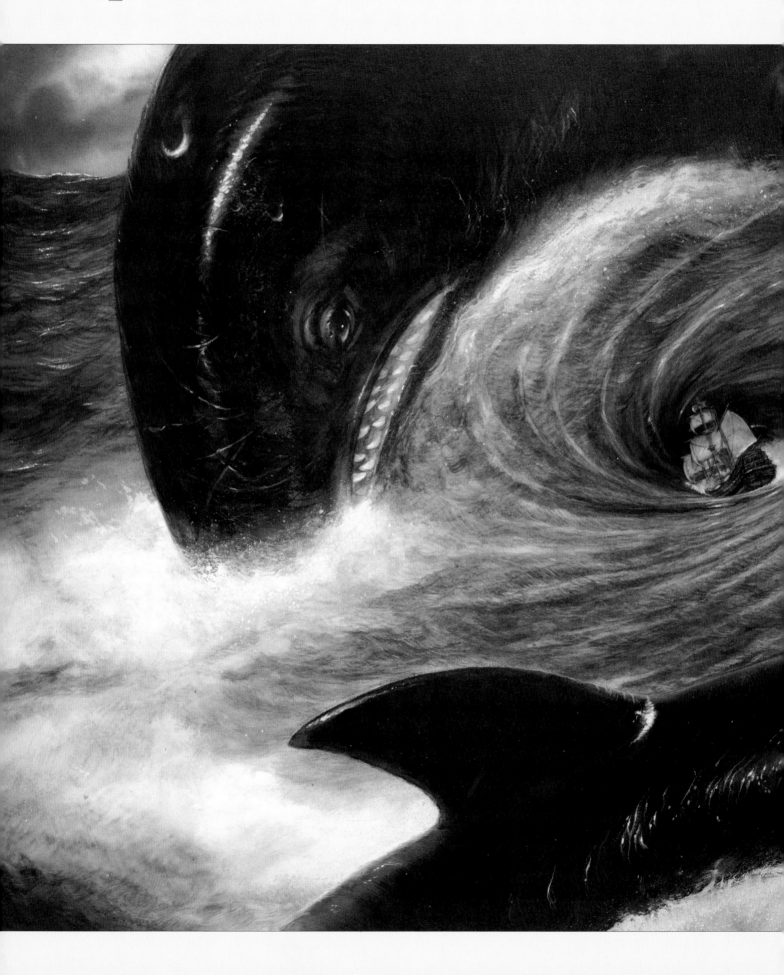

SPINNER OF MAELSTROMS

Of over a hundred paintings done for the Time-Life Enchanted World series, there are only about half a dozen I can still look at without dismay. I would happily do most of them over again, which is a familiar enough sentiment.

I still like the Spinner of Maelstroms, though. Such a lot of effort to sink a wee boat that he could snap in an instant! One day, I'll do the same scene, but from on board the ship.

Spinner of Maelstroms
The Enchanted World Series – Monsters of the Deep,
Time Life Books 1986

A DIVERSITY OF DRAGONS

by Anne McCaffrey & Richard Woods, Simon & Schuster 1997

John Howe has always had a professional reputation of finely and well-researched detail in fantasy art, as for instance, the covers of Irene Radford's splendid dragon books, to name but one cover that springs instantly to mind. In fact, one gets to know by the sweeping line and intricate detail that this illustration has to be by Howe. And how! So he was an obvious person to be contacted to use his scope and range to produce the many types of dragons we required to illustrate in our collaborative effort, 'A Diversity of Dragons', for which Richard Woods and I wrote text on established as well as science fictional dragons. Certainly 'Diversity' gave John full scope for his imagination and artistry and he had a few more to add to this collection as a bonus.

I have also acquired his book on Medieval Armor and found it as detailed and credible as his diverse dragons. You can almost see how full armor compresses a man into his skeleton and feel the weight of the heavy swords, the drag on a man's arms to wield such weapons. No wonder his knights look so authentic! No wonder he was able to design so many different kinds of dragons. There were a few we left out, believe it or not, and there have been newer ones coming upon the scene – not all having been illustrated by Howe. (poor things)

So this monograph will be very welcome to me, as I hope it is to you, showing how Fine Art – and fine artists – attract more book buyers by the cover!

Anne McCaffrey

Lancelot

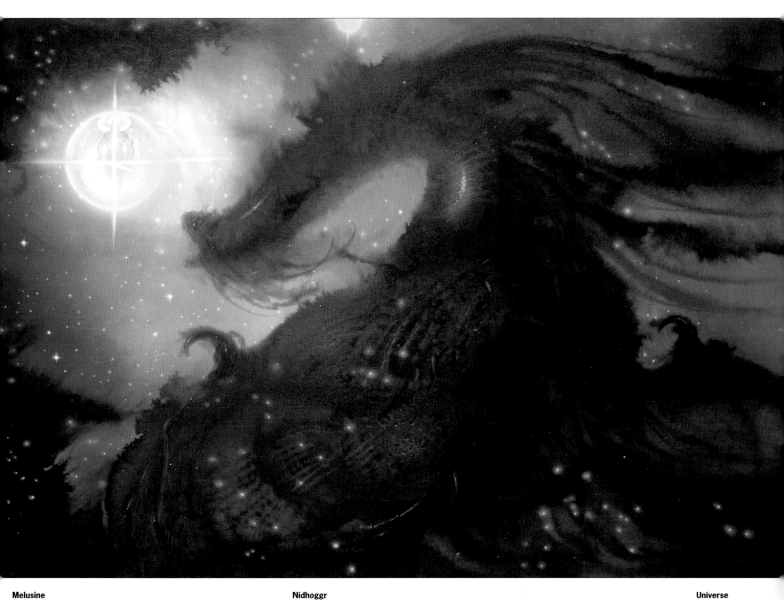

Nidhoggr

Melusine

Universe

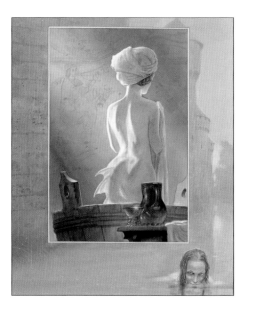

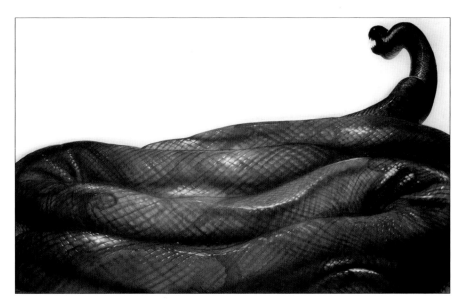

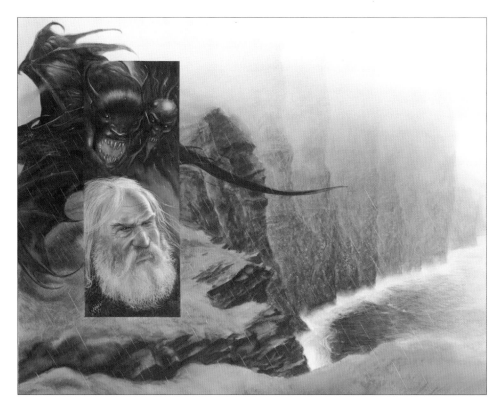

Beowulf and Grendel

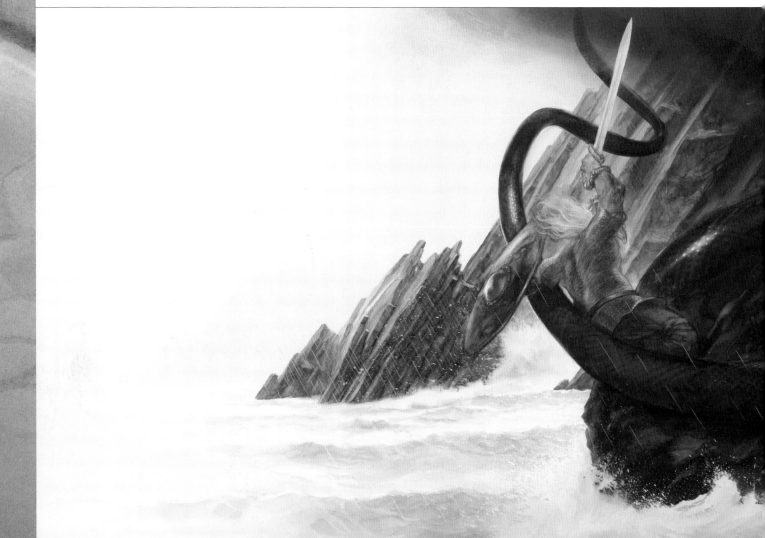

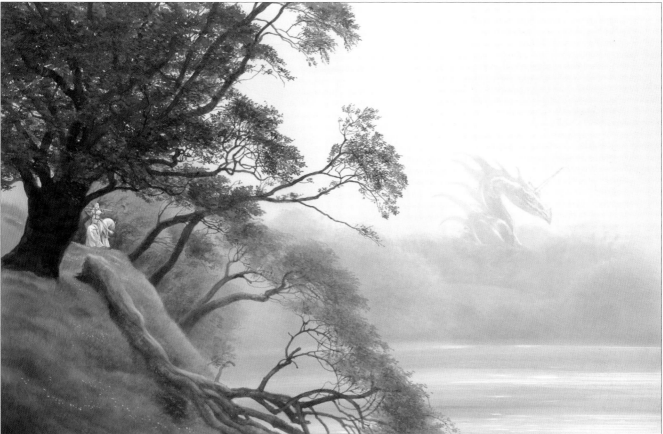

The Red Cross and the Dragon.

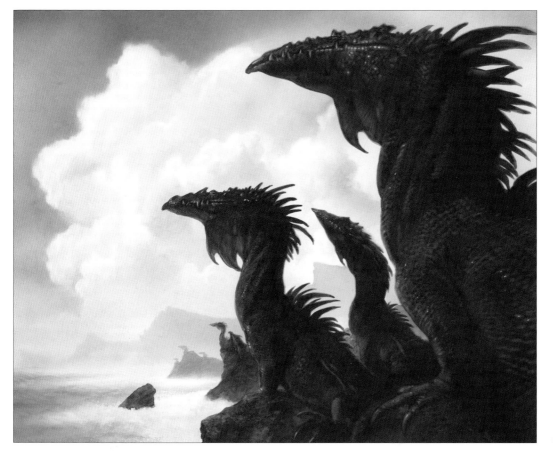

Galapagos

I love dragons for the incredible pictorial possibilities they offer. It's hard to imagine another family of mythical creatures so multifarious. They are absolutely bristling with claws, fangs, horns and the like. They have bat's wings the size of a 747's, glistening scales to render, and even better, many of them breathe fire! Disappointingly relegated to the role of folk-tale extras from the Renaissance onwards, they become grander as you walk back in time. Orobouros, Nidhoggr, Fafnir or Beowulf's bane, those worthiest of worms are pure visual archetypes.

J.R.R. Tolkien deserves credit for restoring these magnificent creatures to modern fantasy. Dragons have never been the same since…

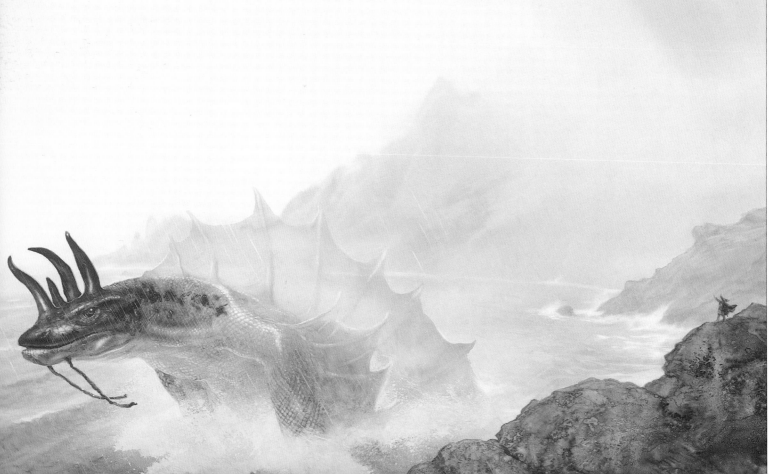

Overleaf: St. George & the Dragon
unpublished 1996

Left: The Last of the Dragons
unpublished 1982

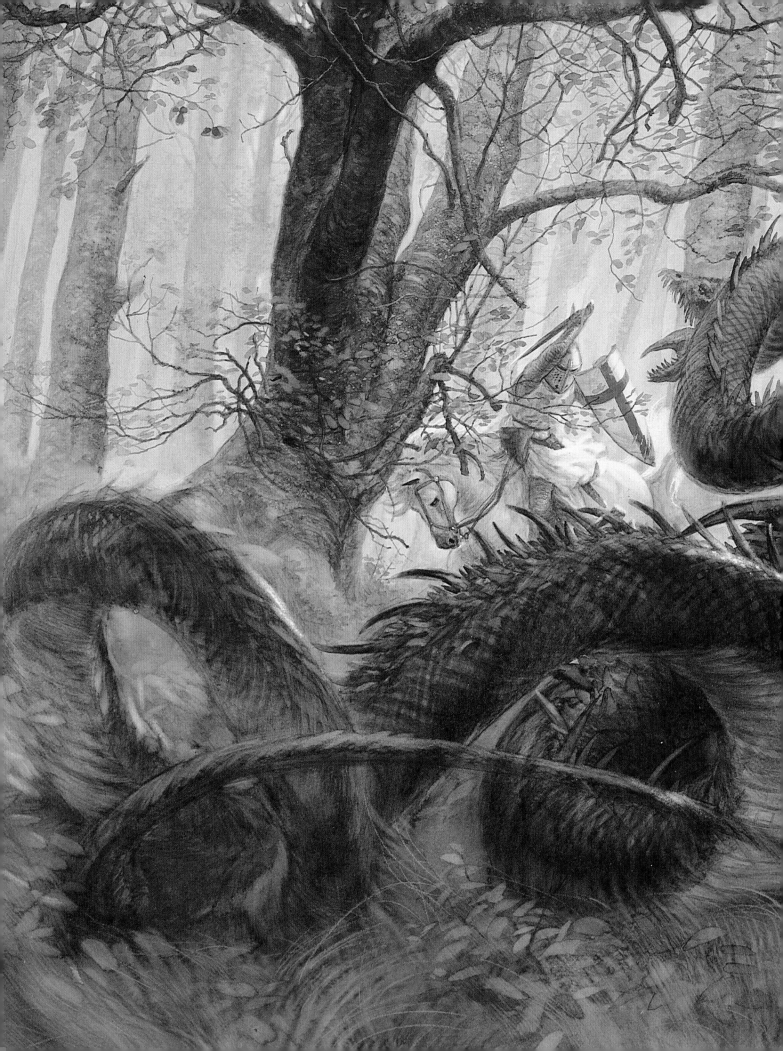

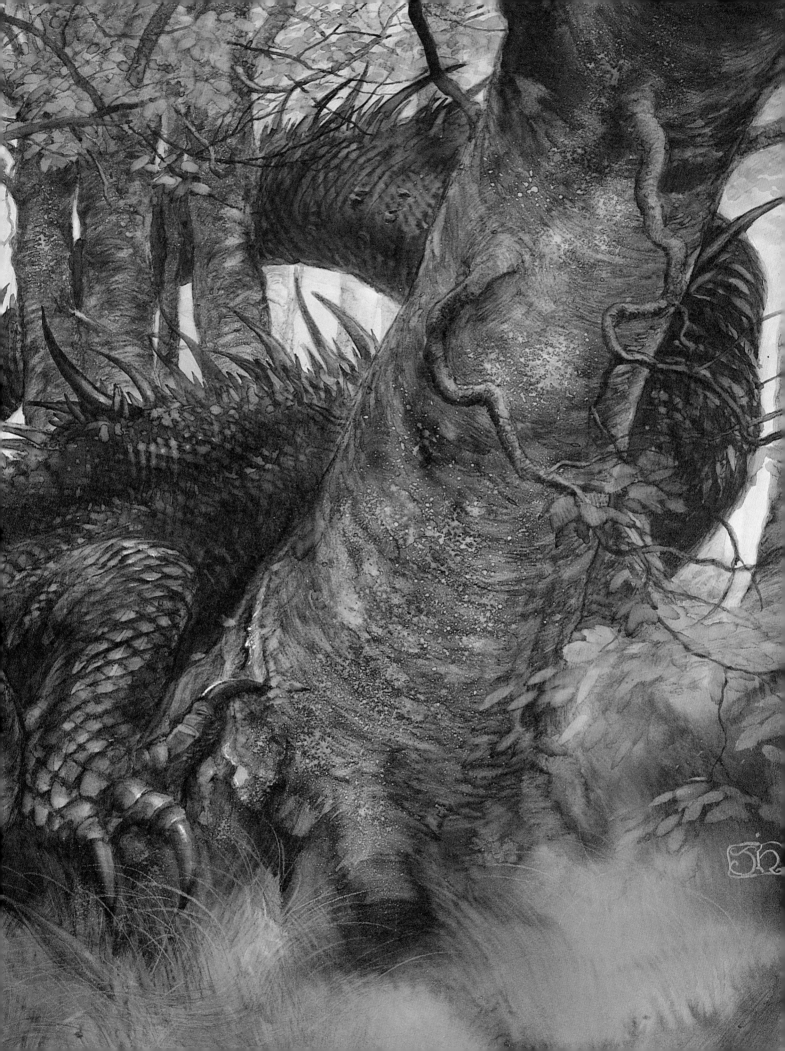

YVAIN, THE KNIGHT WITH THE LION

I've always loved Arthurian legend; no other myth cycle covers a millennium of history, from the Mabinogion to Mallory, from the Celtic precursor of Arthur to the ultimate quest of Galahad. Chrestien de Troyes occupies a special place here. Inventor of the novel, his stories are lively and full of insight, if a little rambling for modern readers. Yvain had to be substantially shortened to fit the strict 32-page picture book format, but the integrity of the story is intact. Readers often ask why the lion is white. I'm sure there was some obscure but perfectly logical reason, if I could only recall…

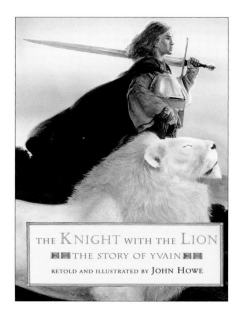

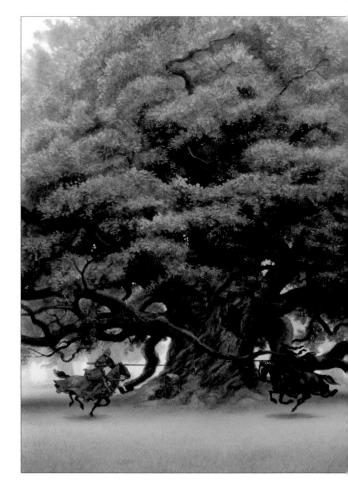

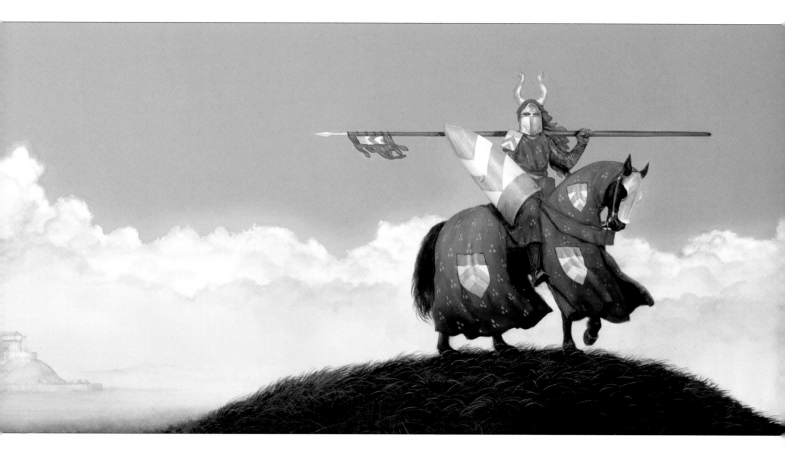

Lancelot
unpublished 1983

Knights by John Howe, Tango Books 1995

The Knight battles two Giants
The Enchanted World Series
Time-Life Books 1986

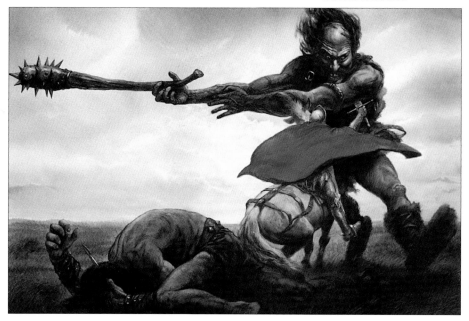

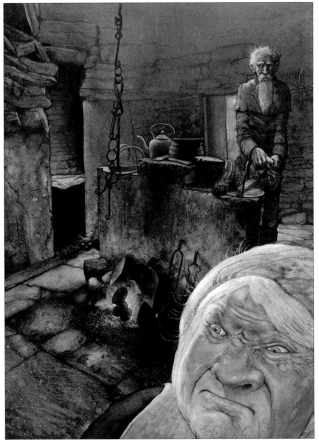

**The Edge of the World, Vespucci
by Gerard Jaeger, Editions La Joie
de Lire 1990**

**Above: The Fisherman and his Wife
by the Brothers Grimm, Creative
Education 1989**

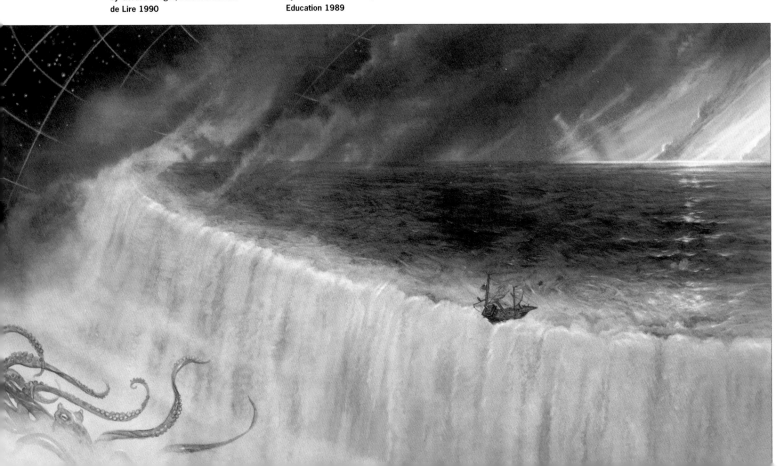

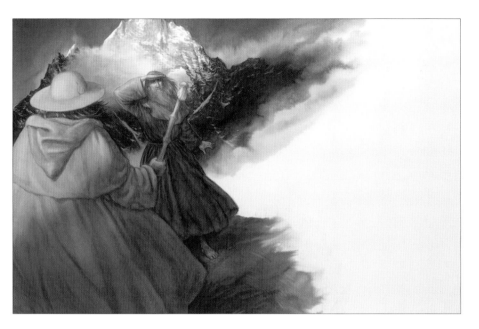

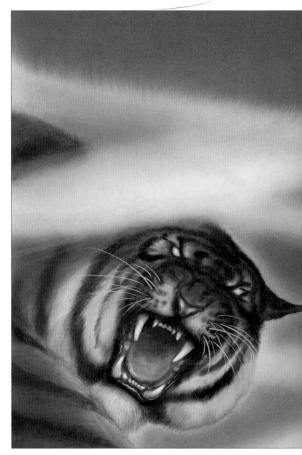

CHILDREN'S BOOKS

Children's books are enormous fun to do, and allow a lighter treatment than book covers. Illustrating a narrative is also more appealing than capturing a story in one picture, and the demands of the genre – especially the rule that picture and related text must be on the same spread – make it an exacting but clearly-defined task. Writing children's books is even more fun, but much much harder – proof that the adage "a picture is worth a thousand words" does not always demonstrate a constant rate of exchange.

Above left: Meeting God L'Histoire d'un Homme:
Nicolas de Flue by Daniel Anet & Claude Martingay,

Above: Tiger, the Mystery of Greenwood
by M. Ferdjoukh, Bayard Presse 1991

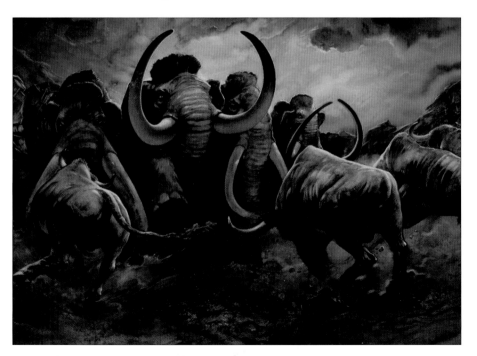

Rana-la-Menthe

(Quest for Fire) La Guerre du
Feu by J.H. Rosny Aîné,
Gallimard 1984

THE ABANDONED CITY

The Abandoned City is another text by Claude Clément, and is about intolerance, of the nature of beauty and the passions it provokes. In the end, the perfect note destroys the singer, and nature revenges herself on men and their city. The music is not drowned, though, and takes on a new form at the story's close. It is based on the watercolour of the same name by Ferdinand Khnopff, the famous symbolist painter. Bruges, the model for the city in the story, is straight out of a story-book itself. Built almost exclusively of brick, it has retained more period vestiges than most towns. As for Khnopff's picture, I have rarely seen an image that calls out so strongly for a story to go with it.

We visited Bruges on a hot summer day, lost in a crowd of tourists. Hardly the romantic, mist-shrouded northern Venice I tried to portray, but those are the advantages of illustrating. Bruges is also my favourite colour – a mix of Prussian blue and sepia ink, which can shift from warm to cold with a brush stroke. It should be a standard colour in paint sets.

Claude never insists on a particular environment for her imagery. Therefore, putting pictures to her words is both a privilege and a challenge.

The Abandoned City is to be published by Editions Casterman in 2002.

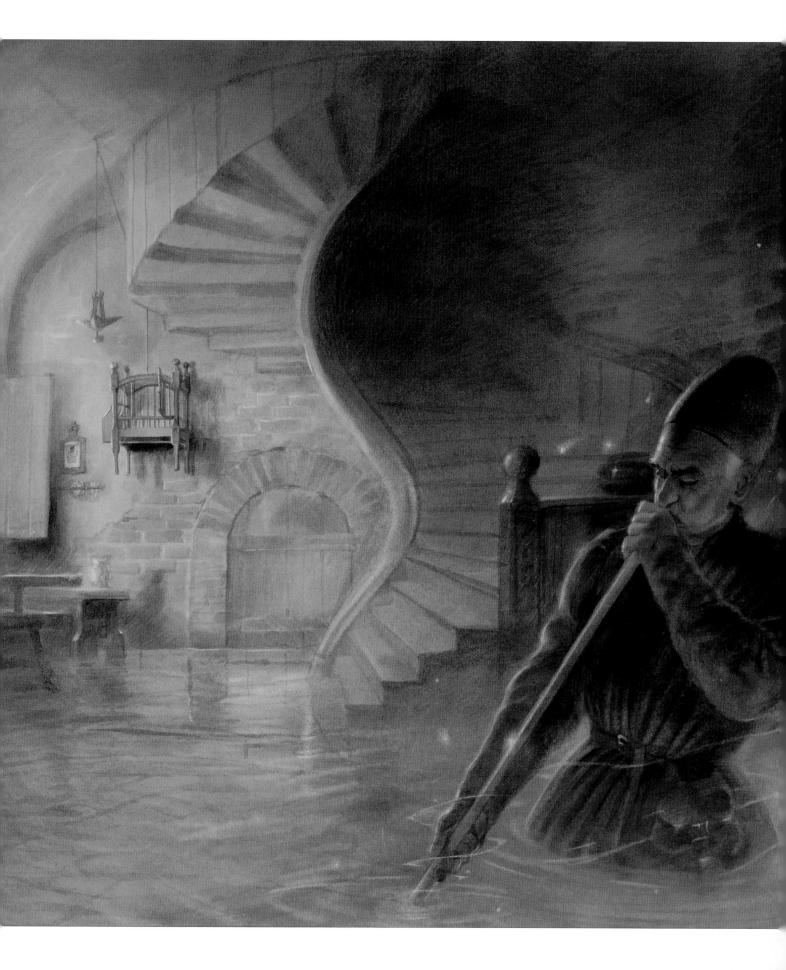

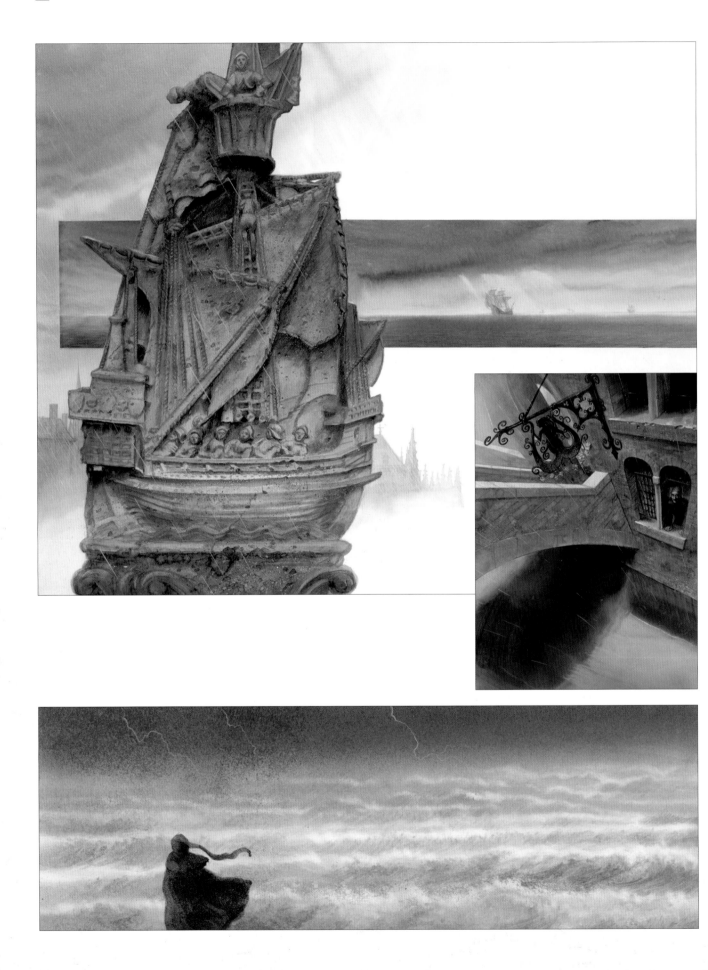

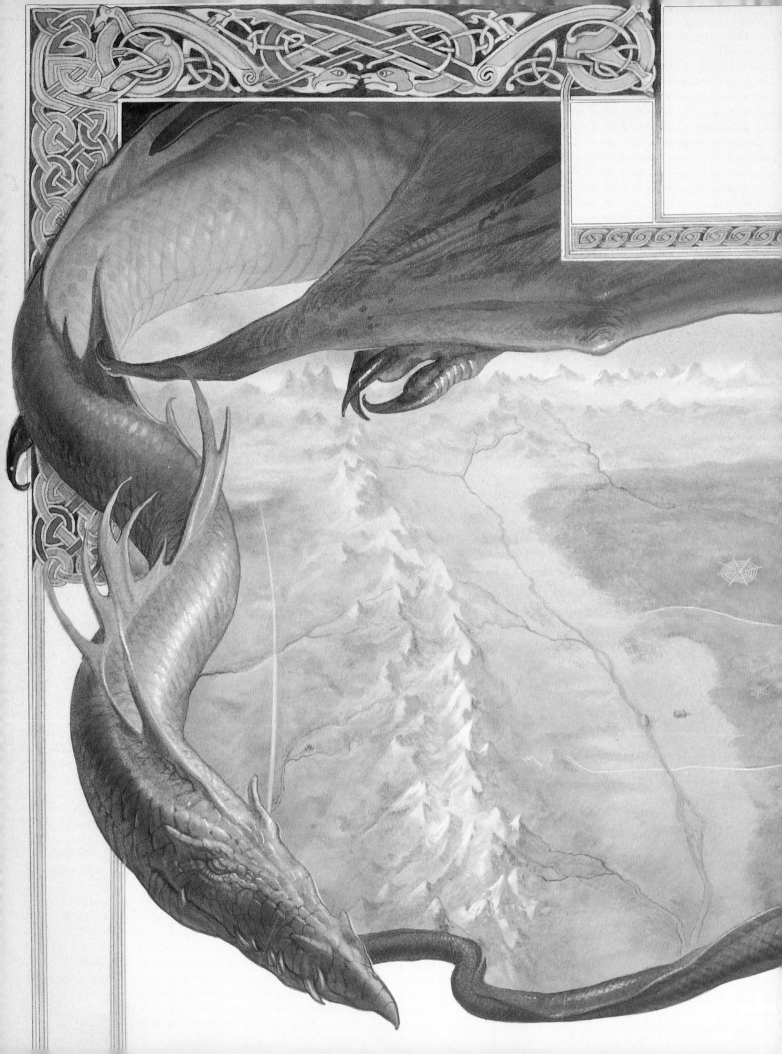

CHAPTER FOUR

BAG END TO WILDERLAND

EARLY HOBBITS

In high school I drew the scene from Riddles in the Dark, then again in art school as a part of a series inspired by *The Hobbit*. While I now find the cartoon style unsuited to the story, I still like the aged, bald crow, Roac, son of Carc. In those days, I was willing to sacrifice verisimilitude for the sake of rendering a few muscles, hence Thorin's rather unorthodox – and unprotective – mail shirt. The first Gollum that I drew had a full head of hair and a straggly beard. Where did I ever get *that* from?

Previous: Smaug decorative border
The Map of Tolkien's The Hobbit by Brian
Sibley, HarperCollins 1995

Right: Mirkwood vignette
The Map of Tolkien's The Hobbit by
Brian Sibley, HarperCollins 1995

Bilbo
unpublished 1979

Below: Bilbo with Beorn
unpublished 1979

Below right: Bilbo with Thorin
unpublished 1979

Gollum
unpublished 1979

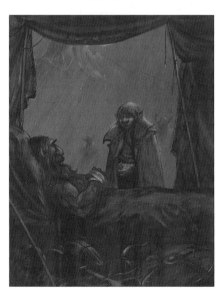

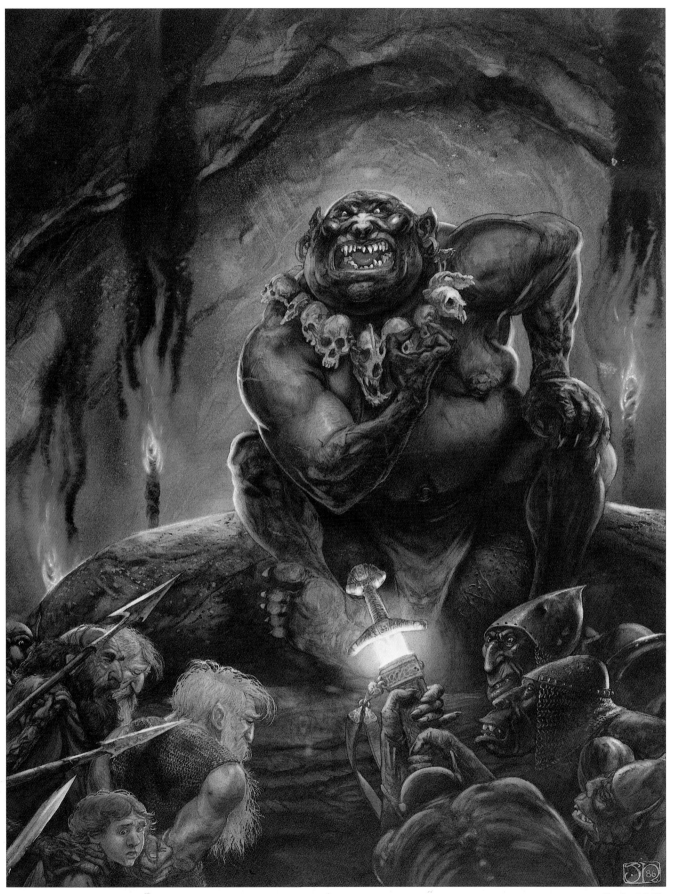

The Great Goblin
Tolkien's World, HarperCollins 1992

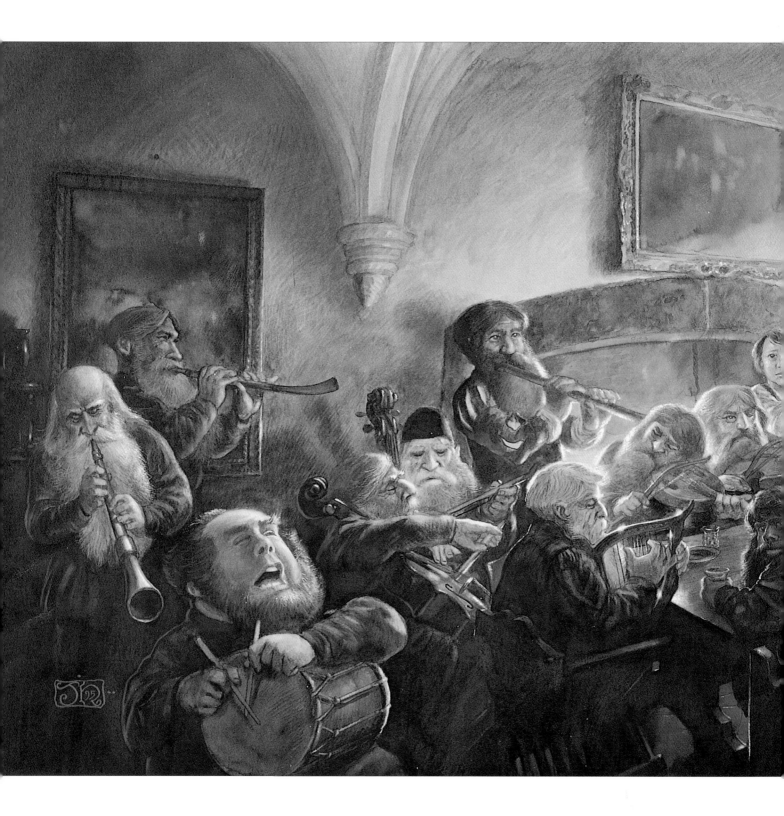

AN UNEXPECTED PARTY

It was quite a job to track down which dwarf played what instrument at the Unexpected Party. I've often wondered what they did with the instruments afterwards, they certainly can't have hauled them all the way to Mirkwood! Perhaps they picked them up on the way back, or are they still lurking in a back room at Bag End…?

An Unexpected Party
The Map of Tolkien's The Hobbit by Brian Sibley,
HarperCollins 1995

SMAUG

Thankfully, the first sketch that I proposed for the cover of The Hobbit — *of Bilbo and the Dwarves in a forest — was refused. I can understand why it was refused, as it wasn't the best choice of image, so I sobered up and sat down and sketched Smaug, which had suddenly become the obvious, emblematic choice for a cover.*

To draw light in a picture, I find it easier to lay down dark washes over warmer ones and then go back in and remove the dark pigment to get back to the light. I admire artists who can just leave those areas white, but I never know where they are going to be in advance. Happily with this one, it all turned out rather well.

It did take some bending of Smaug's supple neck to make the jaws rest on his front legs, like some huge dog in front of a fireplace. Of course that would need to be one hell of a big room…

Smaug
The Hobbit by J R R Tolkien,
HarperCollins 1990

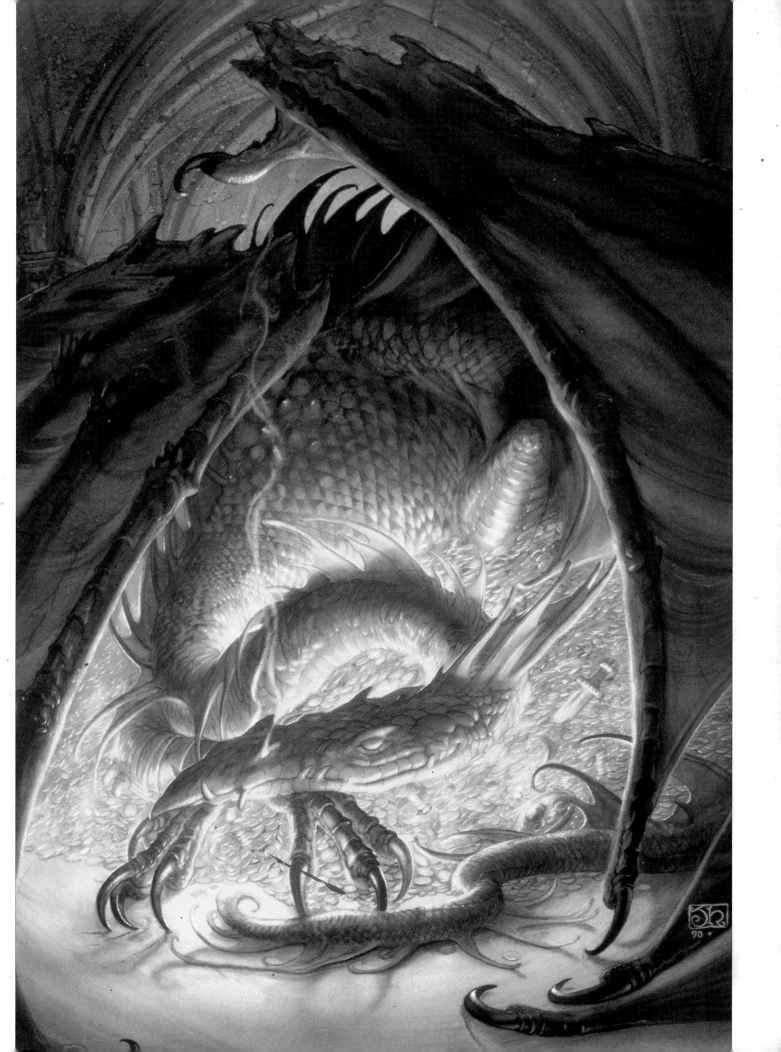

WHY I DON'T DO SKETCHES

(Unless I Can't Help it)

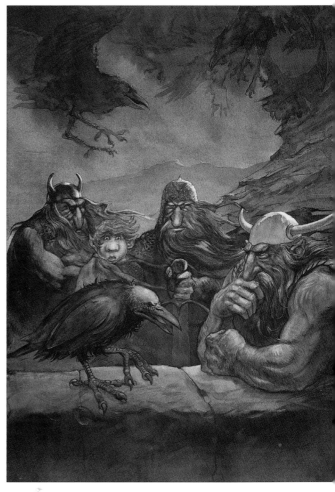

Roac, Son of Carc sketch
Meditations on Middle-Earth,
St Martin's Press 2001

Roac, Son of Carc
Tolkien Calendar 1988,
HarperCollins 1979

Sketches are a necessary evil. They tend to be purely incidental; in no way finished illustrations intended to stand on their own. I admire artists who do attractive sketches, but I find that there are so many directions to take pencil on paper that horses end up with ten legs and humans sprout five extra arms before I have eliminated all the possibilities. Happily, this very sketchiness allows the most interesting bits – especially colour – to happen during the final piece. I rarely do colour sketches, and if I do I find myself miserable afterwards, tied down to decisions that are impossible to make on a small scale. (I also admire artists who do intricate colour sketches, by the way.)

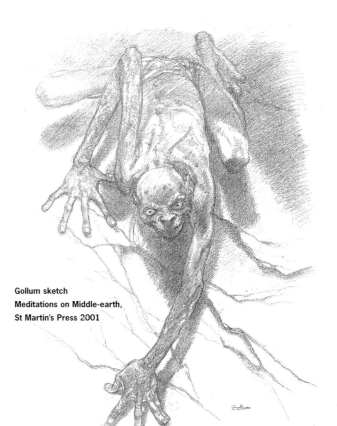

Gollum sketch
Meditations on Middle-earth,
St Martin's Press 2001

The Trolls
Meditations on Middle-earth,
St Martin's Press 2001

Lonely Mountain vignette
The Map of Tolkien's The Hobbit by Brian
Sibley, HarperCollins 1995

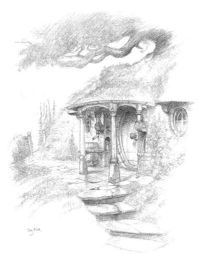

Gandalf upon Gwaihir
Meditations on Middle-earth,
St Martin's Press 2001

Bag End
Meditations on Middle-earth,
St Martin's Press 2001

Overleaf:
The Death of Smaug
Tolkien's World, HarperCollins 1992

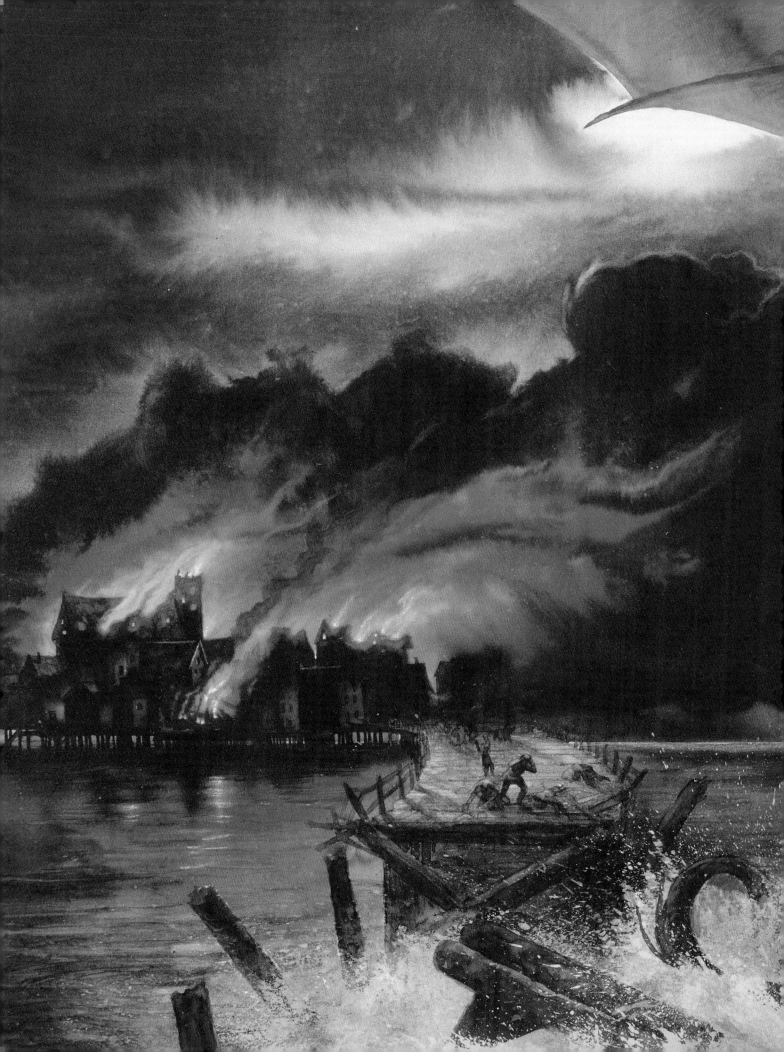

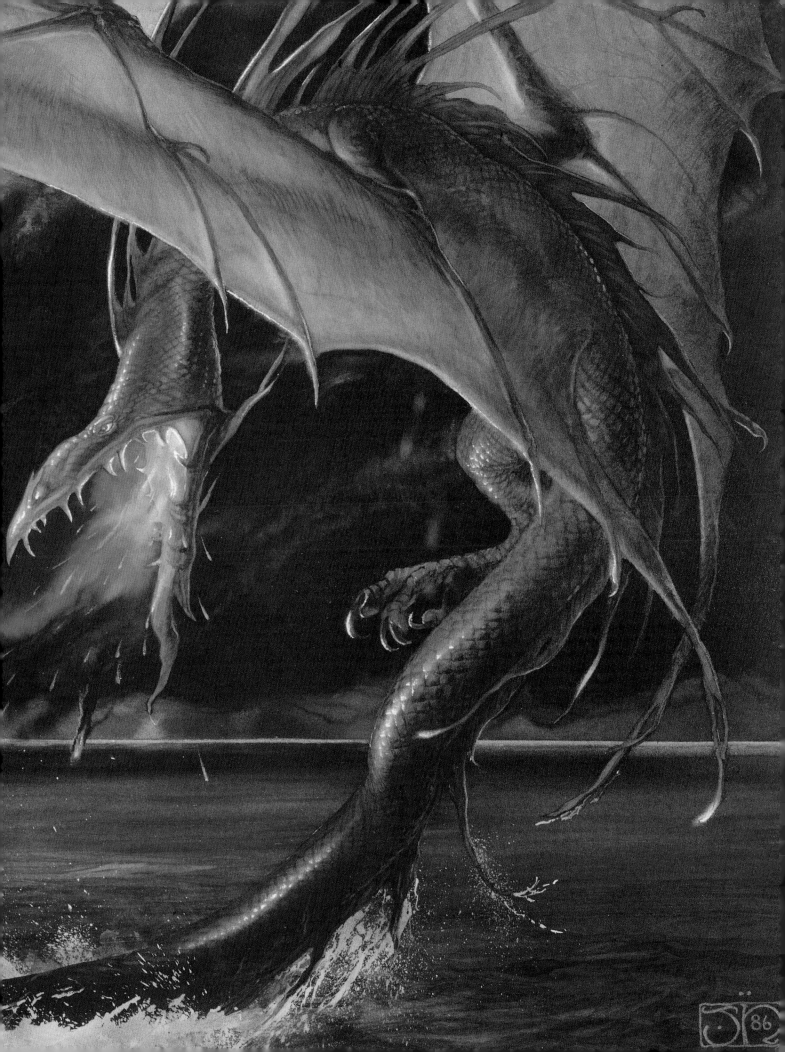

THE HOBBIT 3-DIMENSIONAL BOOK

Working on the 3-D Hobbit was both exciting and frustrating. All of the artwork is in tiny bits and pieces, and making it all fit together is a huge challenge. Paper engineers are artists in their own right. The engineer did a rough layout, to which I did a sketch of the given scene. He replied with a working model, which I adjusted to my illustration, from which he would design the definitive mechanics for a scene. I was given two sets of mock-ups, one working model which would help me understand how it all functioned, and another I could dissect and lay out flat to transpose to my page.

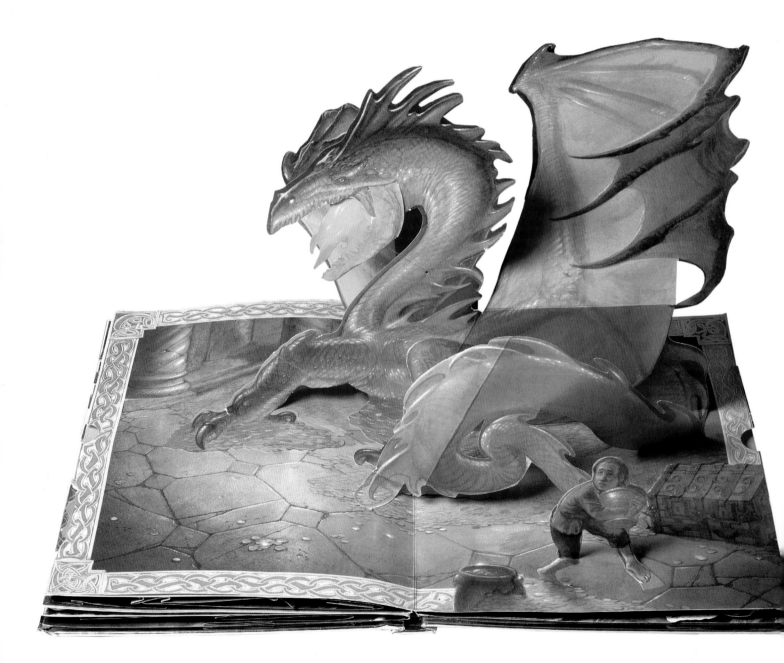

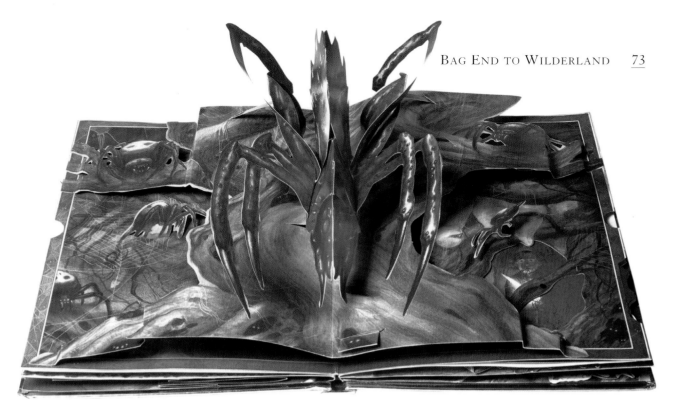

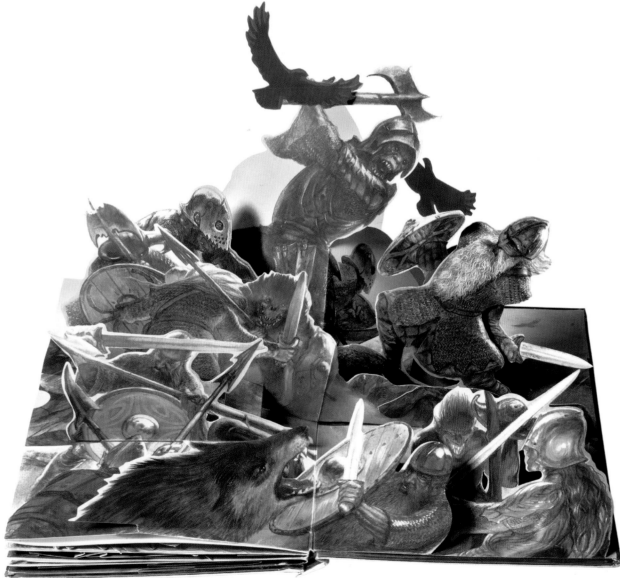

A HOBBIT DWELLING

This illustration is my rendering of J.R.R. Tolkien's drawing of the hall in Bag End. I spent a long time poring over his illustration, coming to grips with the novelty of a house the shape of a tunnel. (I especially love the curved picture frame in Tolkien's picture.) Some of the furniture in my version is in our living room, the timbers and beams come from the insides of ships and Norwegian churches, and the whole is a sort of imaginary Art Nouveau. I would like a house like this, if only I could figure out how to hang up picture frames in it!

A Hobbit Dwelling
The Map of Tolkien's The Hobbit by
Brian Sibley, HarperCollins 1995

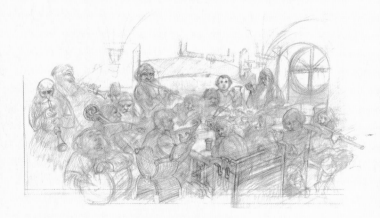

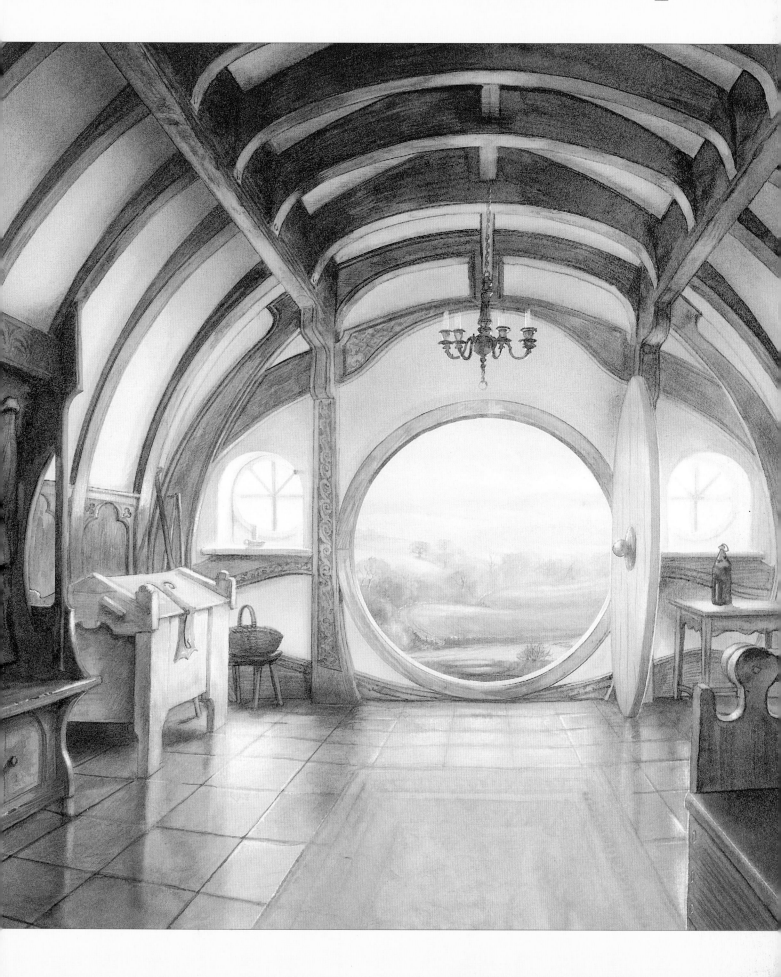

Works of Art

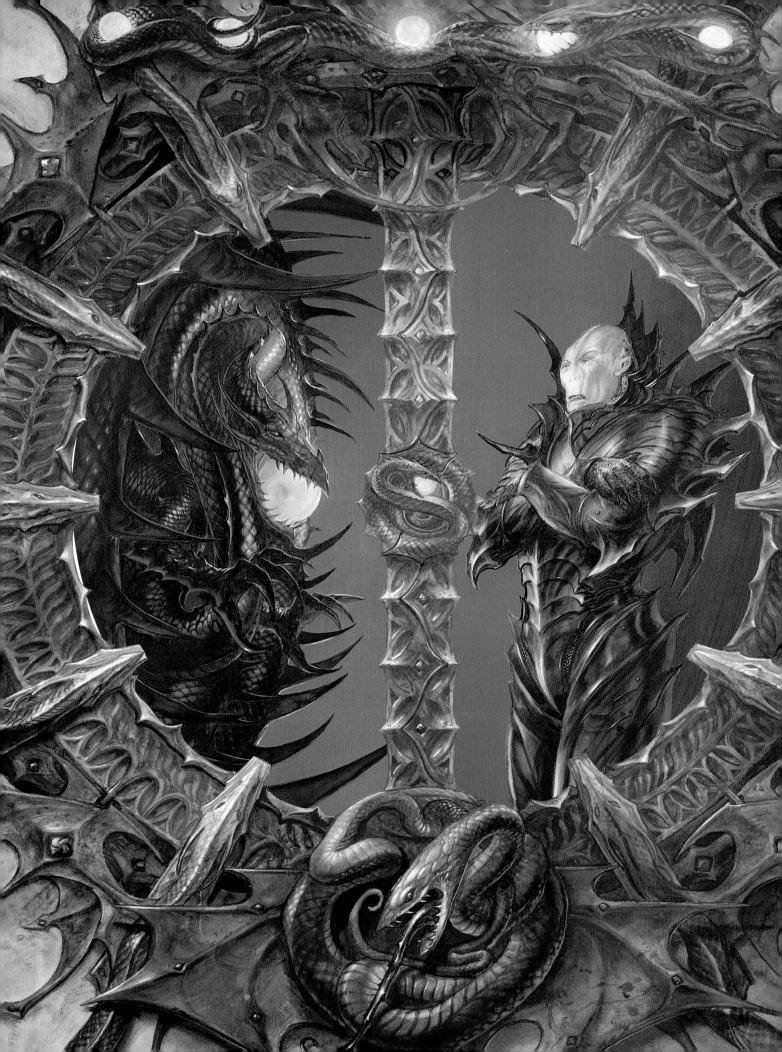

ROBIN HOBB

John Howe: Images from Over the Horizon

I remember clearly the first John Howe cover I saw for *Assassin's Apprentice*. It makes only a cameo appearance on the final cover for the book; Fitz's face, in the top left corner, is a detail

from that original art. The full cover showed a boyish Fitz with his dog leaning up against his leg. Buckkeep Castle towered in the background. I looked at it in dismay and said, 'But that's not how he looks.'

Previous: The Ring of Five Dragons by Eric van Lustbader, HarperCollins Voyager 2000

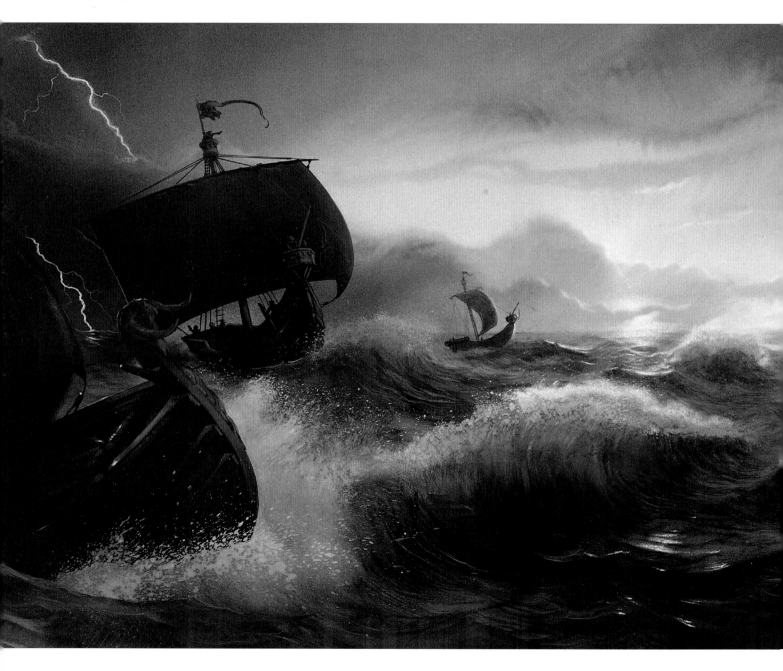

Then I looked again. I recognized both Fitz and his dog from my own descriptions. And I realized that Howe had gotten it all exactly right. His art was more true to the boy I had described than my own glossy school-picture mental image. I had immediately recognized Fitz.

I've had that same experience several times with the covers for the Farseer Trilogy and for the Liveship Traders books. John Howe's images of the characters and settings from my book do not match up with my mental images at all.

They are far better.

Howe has taken my words, my admittedly sparse description, and moved beyond them, over the horizon to where the world I introduced becomes his world. His art has the jagged edges of another reality, one that snags the viewer's attention with detail and colour. There is cover

Assassin's Apprentice by Robin Hobb, HarperCollins Voyage 1995

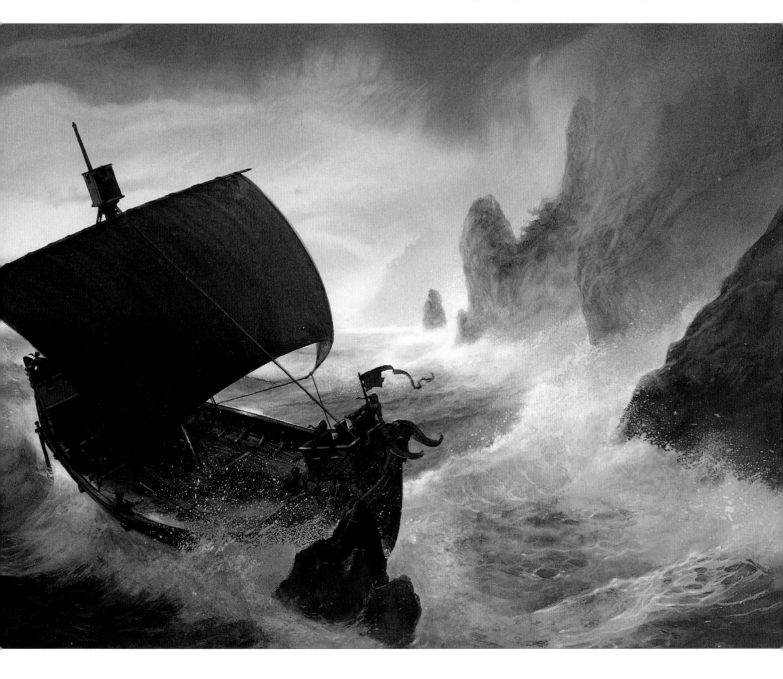

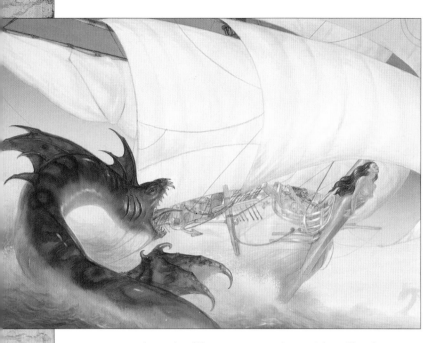

Ship of Magic by Robin Hobb,
HarperCollins Voyager 1998

art that is like a portrait, with all elements balanced into a smooth composition, the subject both poised and posed. To me, Howe's art is more like that rare candid photograph, snapped in an instant, that catches the subject in an unguarded moment, and in that moment reveals a far greater depth of character than any formal portrait. His living creatures, be they human, animal or monster, seem intent on their own lives rather than halted for the viewer's perusal. One has the sense of catching them in an unguarded moment, when true emotions and disposition show in their expressions.

Howe's portraits of the characters do not duplicate my original mental image, yet the moment I see them, I immediately recognize each one. There is Molly, with the

wind blowing her hair across her face, and Fitz, suspended darkly between defiance and self-doubt. The details he captures are often the ones I've left unwritten, the set of a shoulder, the curl of a lip. His portraits are not flattering; far better than flattery is to portray truth. In taking that step, he makes them real people.

He does the same for his creatures, whether it is the dragon sprawled in stony sleep on the cover of *Assassin's Quest* or the serpent and dragon mirroring their shared biology on the cover of *Ship of Destiny*. The fleshed-out reality of the sea serpent on *Ship of Magic* delights me, for Howe has taken the words I used to describe a mythical creature and carried them beyond my horizon, to where serpents gleam as they rise from the waves. Alien as they are, he has anchored his portrayals with the kind of details that convince us, claw and tooth, that in some other world serpents swim and dragons soar.

That other world is captured in a wealth of detail. Each of the covers, including those of the

Assassin's Quest by Robin Hobb,
HarperCollins Voyager 1997

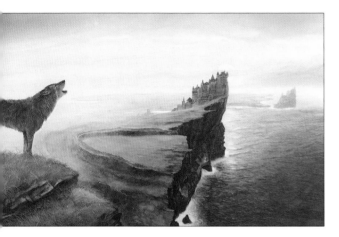

Royal Assassin by Robin Hobb,
HarperCollins Voyager 1996

Ships books, convey a remarkable sense of place. The cover art for *Assassin's Quest* illustrates this perfectly. The subtleties of the portion of the art on the back cover are rich with clues for the viewer to discover. The sleeping dragon dwarfs the human figures, but, in turn, the forest has devoured the dragons and holds them fast. One senses the vastness of the forest in the glimpse Howe has provided. The same is true for the cover art on *The Mad Ship*. There, the rocky beach grips the derelict ship, while Paragon turns blind eyes toward a wide blue sky. The immensity of sea and sky are focused on the stranded ship. Even if one were to remove all fantastic elements from these covers, the viewer would still know he was looking at a legendary landscape. The power of the natural world comes through.

The framed Howe covers of my books grace the walls of my office. When I lose my way in my writing, when the realities of teacher meetings and dental appointments and lawns to mow threaten to overwhelm my Sense of Wonder, those images are there like portals back into my world. It's just a few steps to that horizon.

The Mad Ship by Robin Hobb,
HarperCollins Voyager 1999

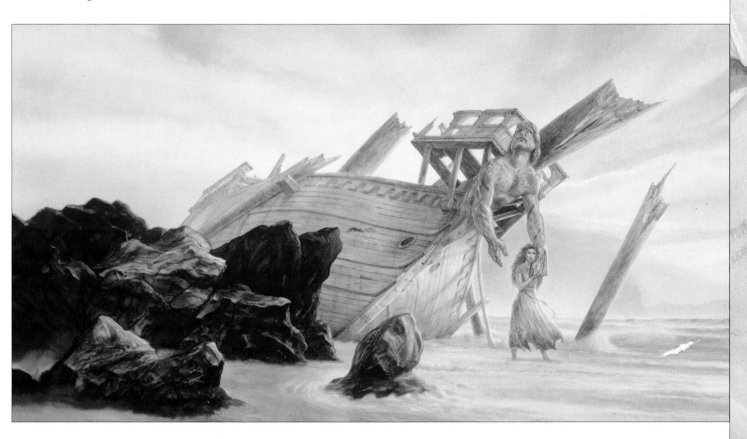

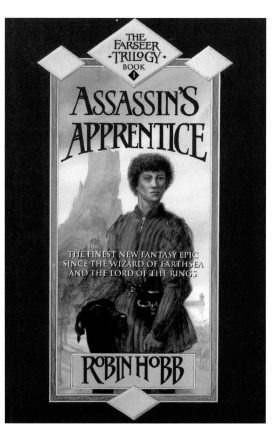

Assassin's Apprentice proof
HarperCollins Voyager 1994

Opposite: Fool's Errand by
Robin Hobb, HarperCollins
Voyager 2001

Ship of Destiny by Robin Hobb,
HarperCollins Voyager 2000

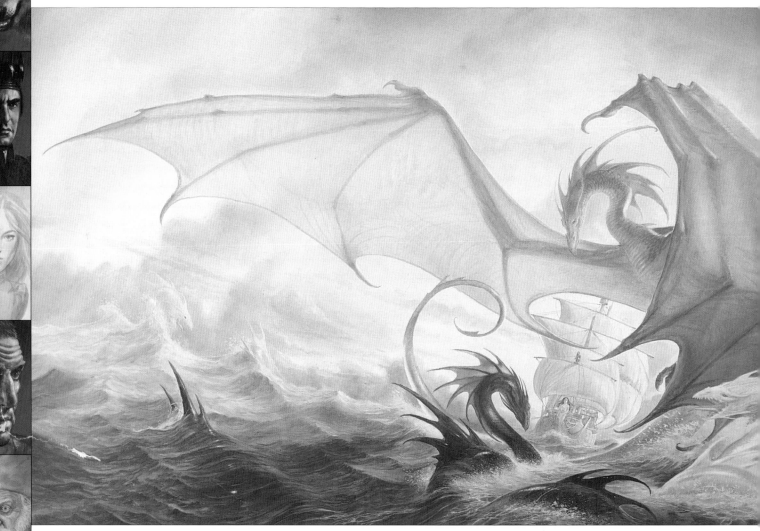

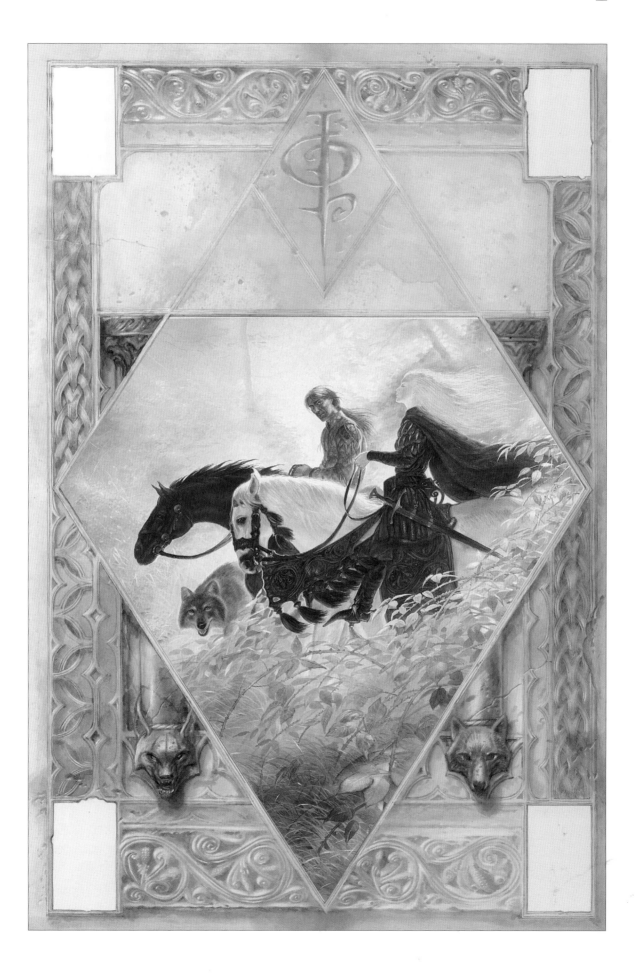

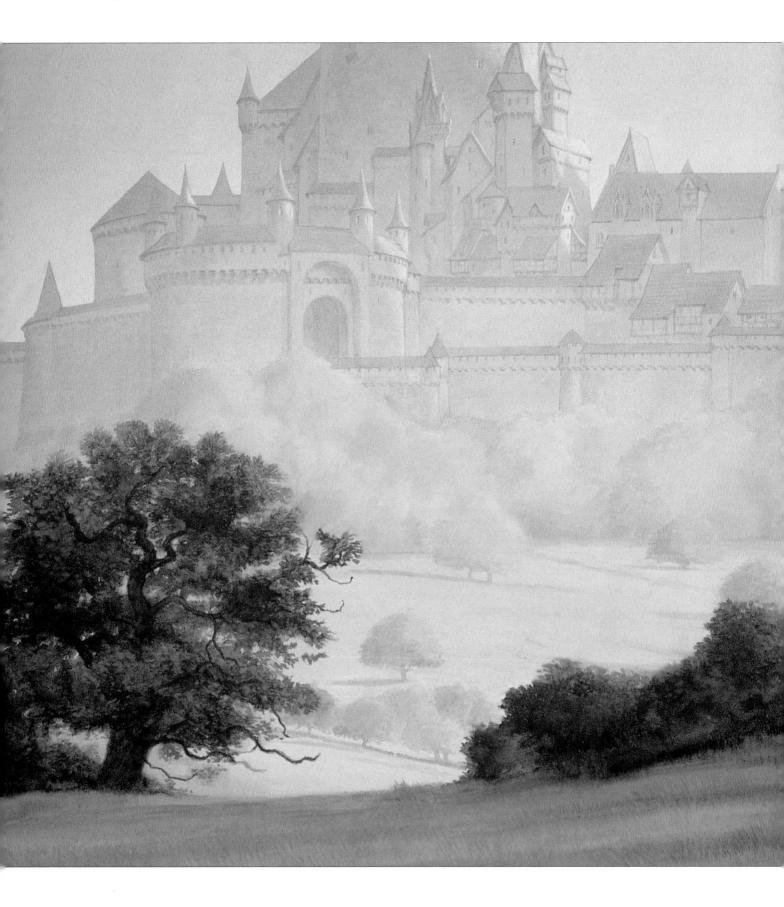

The Once and Future King by T H White,
HarperCollins Voyager 1996

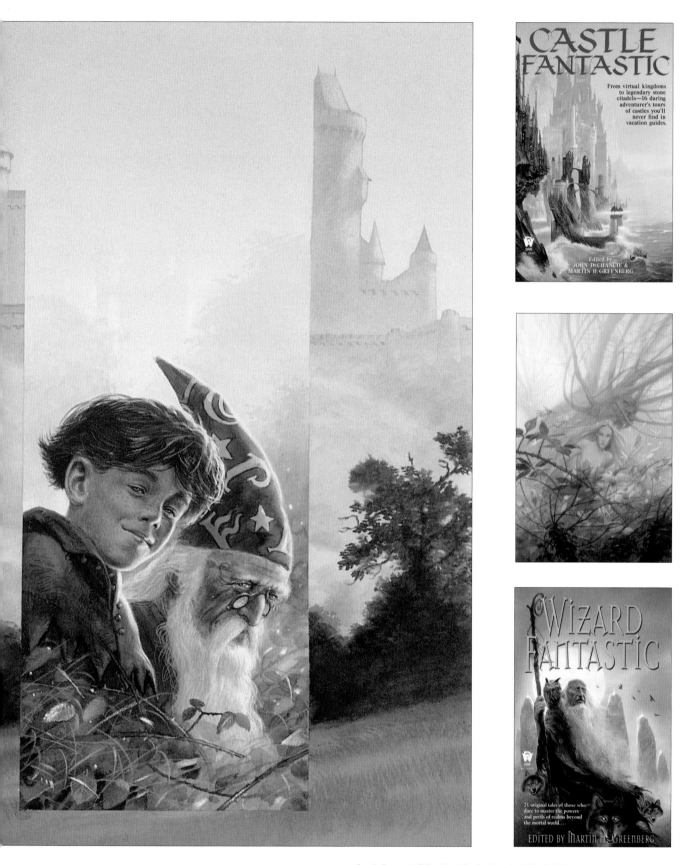

Castle Fantastic Edited by John DeChancie & Martin H Greenberg, DAW Books 1996

Elf Fantastic Edited by Martin H Greenberg, DAW Books 1997

Wizard Fantastic Edited by Martin H Greenberg, DAW Books 1997

GARRY KILWORTH

I had no idea weasels were so complicated. Horses, fell beasts, serpents of all sorts are a recreation compared to weasels. They are practically indistinguishable to my layman's eyes from ferrets, stoats and a myriad of other diminutive furry carnivores. And to top it all off, Kilworth's crowd are armed (and dangerous) but not dressed, which makes them even harder to render. (You can hide so much approximate anatomy behind cloaks, hoods and thigh boots...) Last but not least, how do you get any scope in a landscape when the main character is not much bigger than your thumb?

And is that distinctive scar over his left or right eye? All that, and trying to convince the local Natural History museum that I just had to borrow their stuffed weasel...

Below: Castle Storm by Garry Kilworth, Corgi 1997

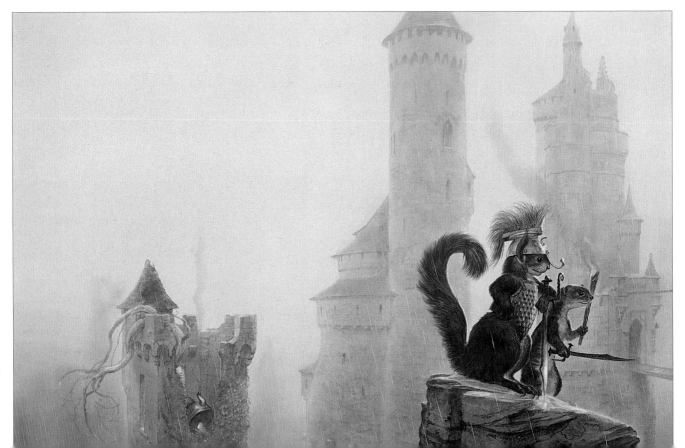

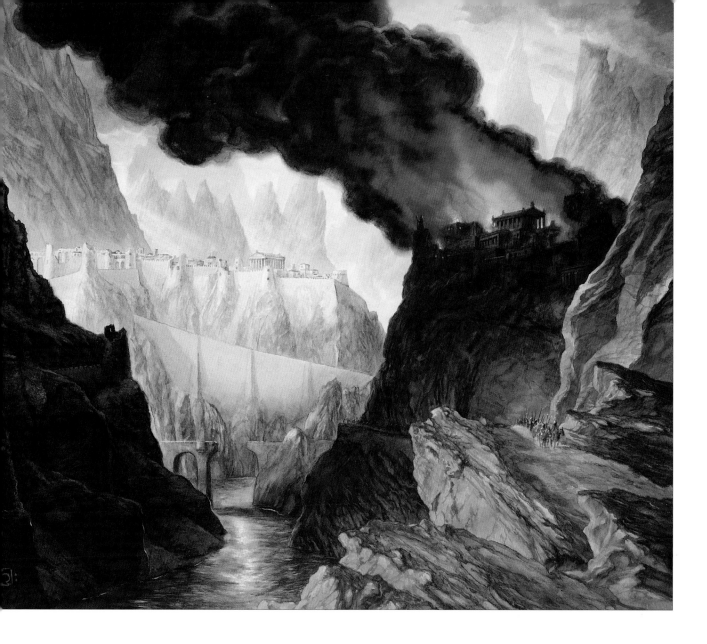

Above: The Sword and the Lion by
Roberta Cray, DAW 1993

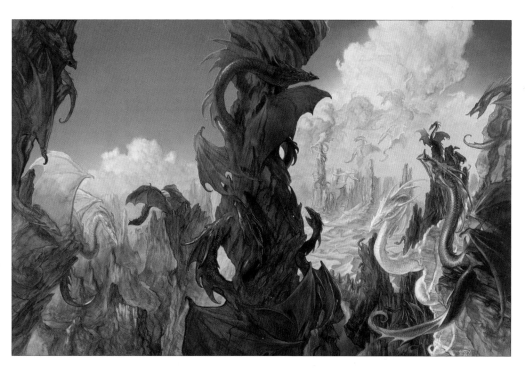

The Cygnet & the Firebird by
Patricia A McKillip 1993

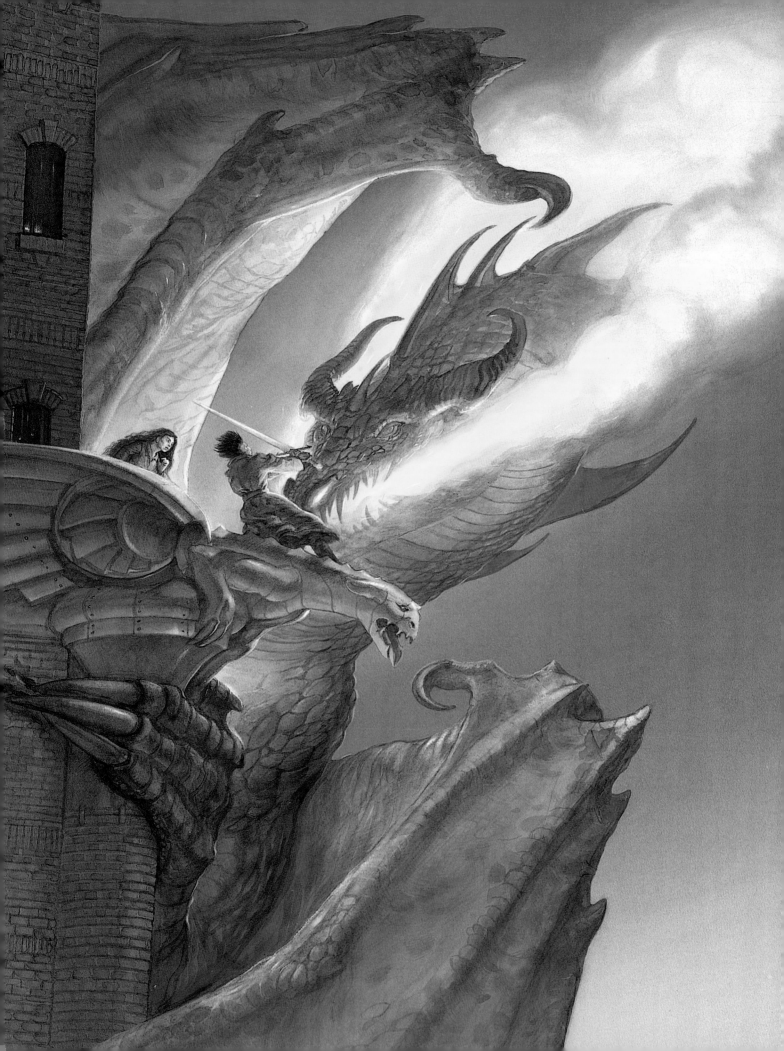

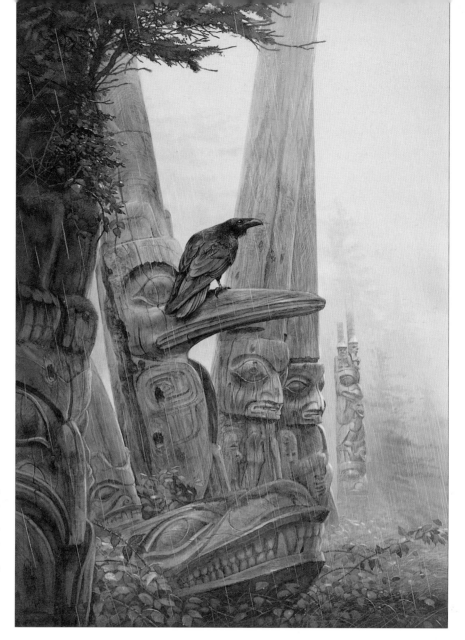

Opposite: Dark Heart by Margaret Weis
& David Baldwin, HarperPrism 1998

Winter of the Raven by Janice Kay
Johnson, Tor Books 1994

Earthdawn: Throal, The Dwarf
Kingdom, FASA Corporation 1994

Grailquest: Kingdom of Horror,
Gallimard 1986

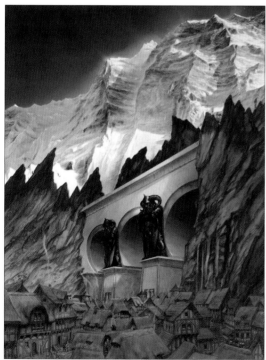

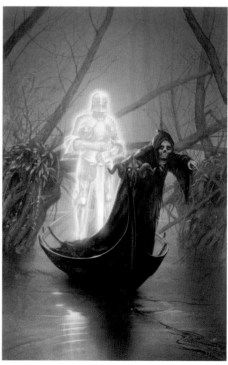

ROBERT HOLDSTOCK

In the twenty-one years since *Mythago Wood* first emerged from its primeval past, there have been just as many images of Guiwenneth of the Green depicted on covers of the book worldwide. She is the most important 'mythago' in the cycle, a Celtic princess. She is sometimes shown as pale and wan, elemental, mysterious. More usually she is a close cousin of Xena! Tough, busty, armoured, thigh-boots polished to a high sheen.

John Howe has captured her very much as I imagined her from the beginning:

'Her face was quite startling, pale-skinned, slightly freckled. Her hair was brilliant auburn,

and tumbled in unkempt, windswept masses about her shoulders. I would have expected her

Gate of Ivory by Robert Holdstock, HarperCollins Voyager 1998

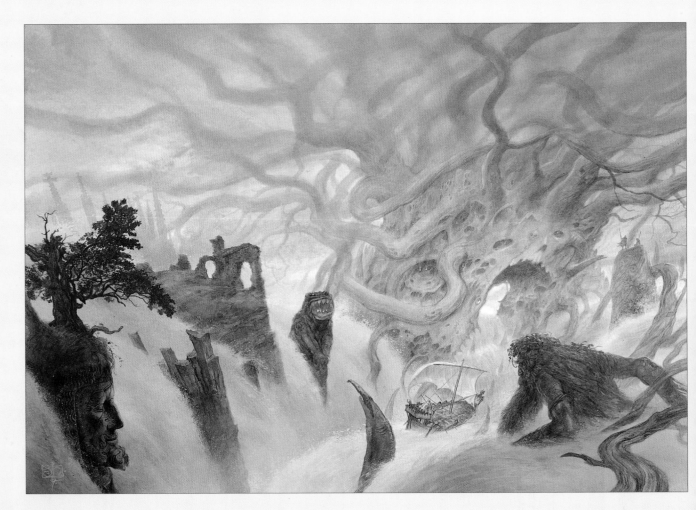

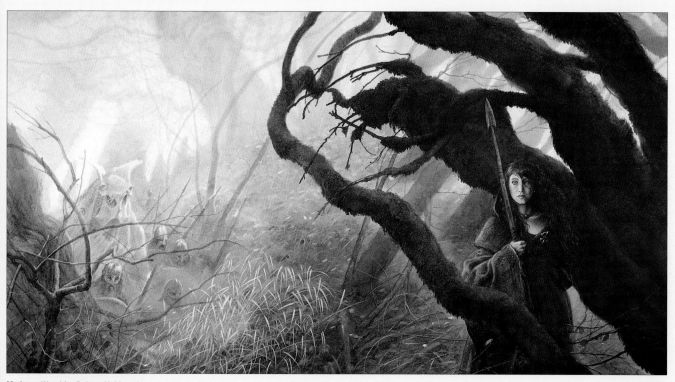

Mythago Wood by Robert Holdstock,
HarperCollins Voyager 1998

eyes to be green, but they were a depthless brown, and as she regarded me with amusement, I felt drawn to that gaze, fascinated by every line on her face, the perfect shape of her mouth, the strands of wild red hair that lay across her forehead.'

What John Howe has also managed with this portrait is to signal both the poise and courage of the woman, and her vulnerability, the slightly haunted look of someone who is not quite sure of where she is, or what is happening. Guiwenneth in every way.

I did not base the character on anyone I knew. I have never met her.

Oddly, she is so strongly present in my mind that I miss her when she doesn't turn up at my parties.

Gate of Ivory is both sequel and prequel to *Mythago Wood*, part of the same story told, in detail, from a different point of view. Whereas

Mythago Wood is populated by fragments of myth, *Gate of Ivory* has a cast of hundreds, all of them dreamed into existence by the narrator, Christian Huxley. One of my favourite characters is Elidyr, shown here, who transports the Dead in their little boats to the Otherworld, holding them steady against the raging torrent of the river. He occasionally gives in to the pleading of mortals and gives the Dead a brief respite in life.

John Howe's painting wonderfully suggests the turmoil both of the man's deeds and his conscience; the flow of Life kept back from Death, but just for a while. A great struggle. To the left, dreaming, his mind enclosed by the wildwood: you and me. Our dreams are 'where the mythagos grow'. This is a painting full of fun, full of energy, full of meaning.

Robert Holdstock

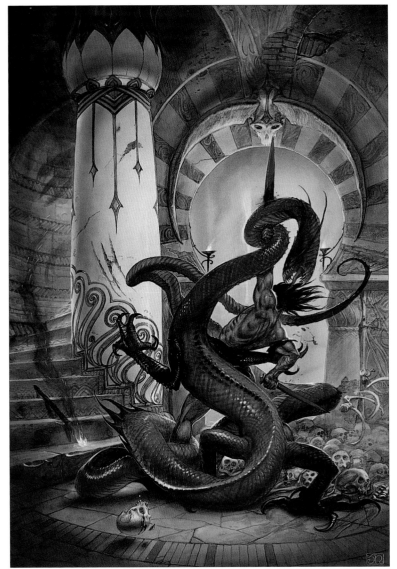

Conan
The Conan Chronicles Vol. 2
by Robert E Howard, Orion 2000

Merlin l'enchanteur
Fantasy Art of the New
Millennium 1999

Opposite above: Sir Gawain & the
Green Knight, Pearl and Sir Orfeo by
J R R Tolkien, HarperCollins 1995

Opposite below: Finn & Hengest
by J R R Tolkien edited by Alan
Bliss, HarperCollins 1998

Pearl & Sir Orfeo by J R R
Tolkien (cassette), HarperCollins
Audio Books 1997

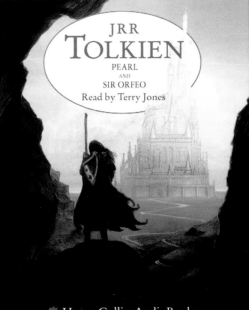

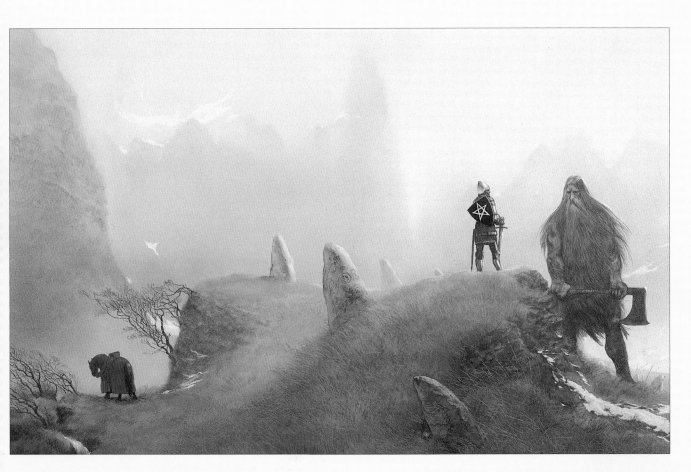

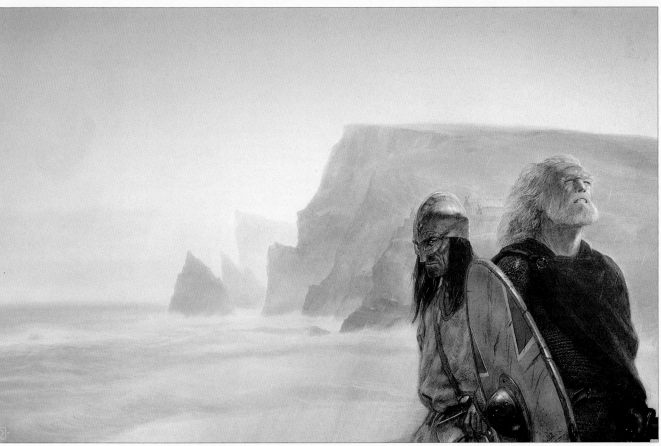

DAVID GEMMELL

Winter Warriors by David
Gemmell, Bantam 1997

David Gemmell's fantasy worlds are full of dust and grit and dead grass. So many fantasy universes are so self-consciously novel and original, caught up in mapping out kingdoms and coastlines, insisting on a patchwork of cultures to achieve a feeling of reality. David Gemmell does not bother. He is an illustrator's author. His brief hints of architecture are smudged by blowing dust, and you have to squint against a low sun to make them out. He never bothers with lengthy descriptions of arms and armour, but you can nonetheless feel the chafing of straps, and the grit between mail. His landscapes are parched and

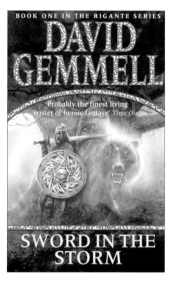

Sword in the Storm by David
Gemmell, Bantam 1998

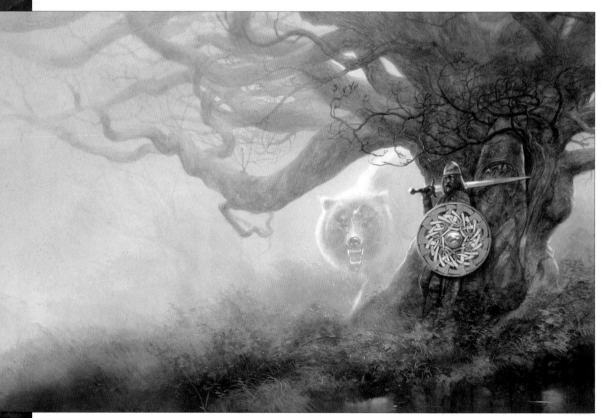

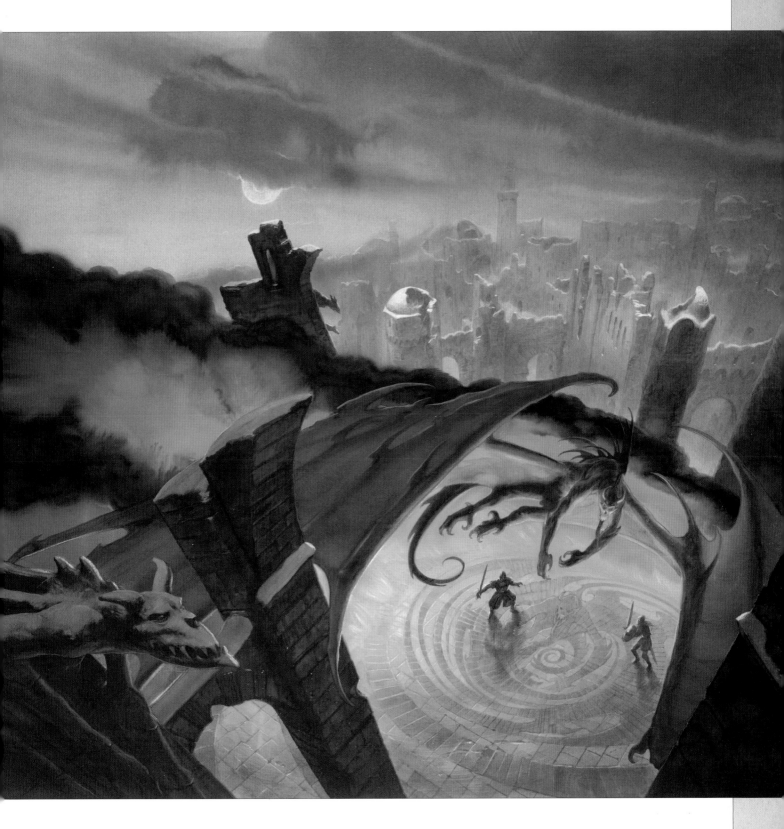

windswept, there is always a mat of dead growth and twisted roots underneath spring's brief green.

He does the same for his heroes - more sinew than steroids. They carry scars inside and out and move against a backdrop of melancholy and emptiness.

Incredibly fertile ground for your imagination to take root in.

Echoes of the Great Song by David
Gemmell, Bantam 1997

ECHOES OF THE GREAT SONG

Echoes of the Great Song was done as a full wraparound hardcover jacket – with flaps! – and somehow ended up as a front-cover-only paperback. While I honestly enjoy seeing my pictures covered in titles and type (they are meant to be, after all) it's a pleasure to see the whole picture as it was intended.

SCIENCE FICTION

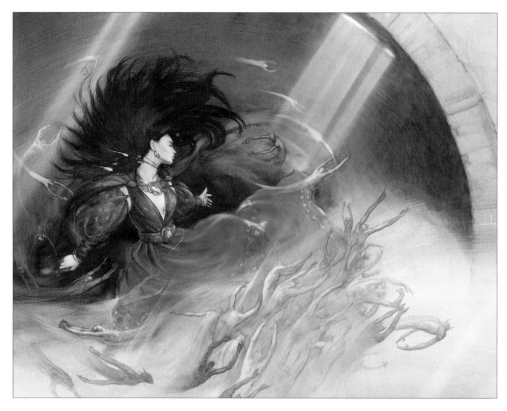

I would happily do much more science fiction, if I could find the excuse. I would like to convey a pre-industrial feel to it, as if the world had gone straight from bombards to blasters, from steam engines to space stations. It's also a good place to indulge in a few extra horseshoe crabs!

Clockwise from right: The Secret Sharer
The Collected Stories of Robert Silverberg,
Volume 2, Grafton 1993;
Altaïr 13, decoration for the Maison d'Ailleurs.
Pluto in the Morning Light, The Collected Stories of
Robert Silverberg, Volume 1, Grafton 1992;
Persistence of Vision, exhibition poster for the 22nd
French Science Fiction Convention;
Chimeras by Christopher Evans, Grafton 1992

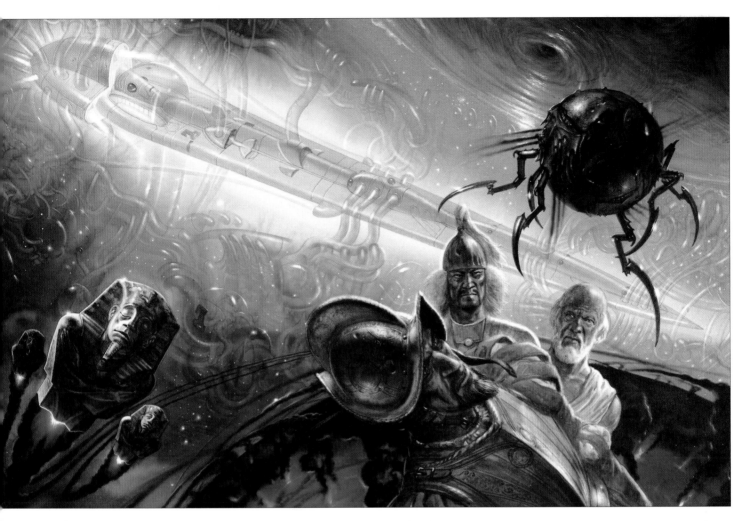

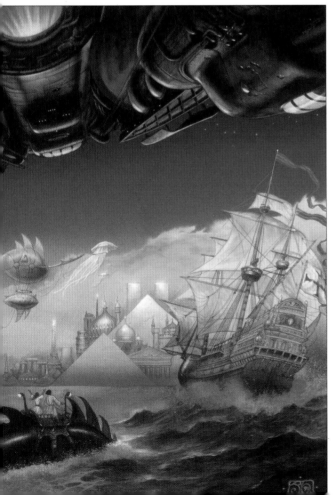

CHARLES DE LINT

Though we all know better, we still judge a book by its cover. For that reason, to an author who might have spent a couple of years working on a book, there's nothing more discouraging than having your editor send you an advance look at the first impression your book is going to make on the world and it's awful.

That awfulness can take different forms. It might simply be bad art.

It might be good art, but a poor design. It might good art and well-designed and have nothing whatsoever to do with what's actually in the book. It might be all of the above.

I've left publishers because of inappropriate cover art, so clearly it's something I care a lot about.

When my editor at Tor sent me a proof of John Howe's cover for *Memory and Dream*, I couldn't believe my good luck. Here was a book

about art and artists and creativity, about spirits called into this world through art, and John had gotten everything right.

I don't mean that he used his watercolours to portray the characters that were in my head and put them down on paper exactly the way I saw them.

I mean he captured the *spirit* of the book, which is more important, because if I've done my job right, each reader will form an individual impression of the various characters and settings.

John's cover for *Memory and Dream* is beautifully rendered and exquisitely designed. I love the way the dancing figures start on the back of the book as

Trader by Charles de Lint, Tor Books 1998

sketched-in figures only to develop into fully painted spirit beings by the time you turn it around to the front. There's enormous joy in their movement, in the birches, in the light that fills the final painting.

And it's exactly what the book is about. Yes, there is pain and suffering and sorrow in the pages of *Memory and Dream*, but through it all, the characters reach for joy, or help others attain it.

John's covers for *Into the Green* and *Trader* are also real favorites of mine.

Before Tor assigned these three covers to him, I hadn't really been familiar with his work. Now a Howe cover always catches my eye and, yes, makes me want to pick up the book and read it.

One day, perhaps, I'll be able to afford an

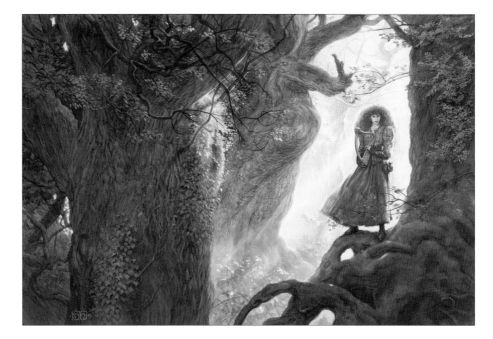

Into the Green by Charles de Lint, Tor Books 1993

original Howe to hang on my wall. Until then, I'm delighted to have this monograph, collecting so many of his fine paintings between covers.

Charles de Lint

Memory and Dream by Charles de Lint 1995

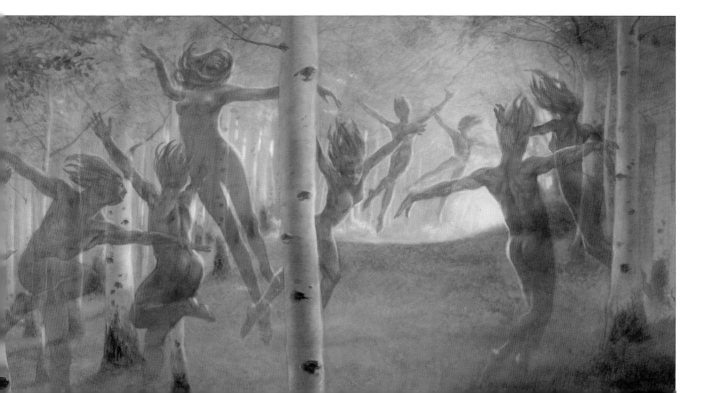

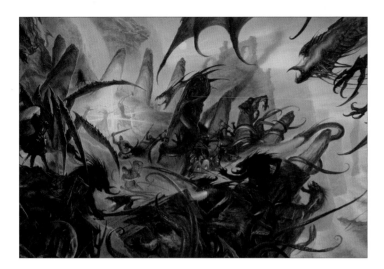

The 4th Coming promotional poster for the on-line computer game, GOA France Telecom Multimedia Jeux 2001

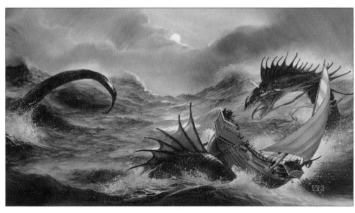

The Wandering Fire by Guy Gavriel Kay, Grafton 1992

A Song for Arbonne (paperback) by Guy Gavriel Kay, HarperCollins Science Fiction & Fantasy 1993

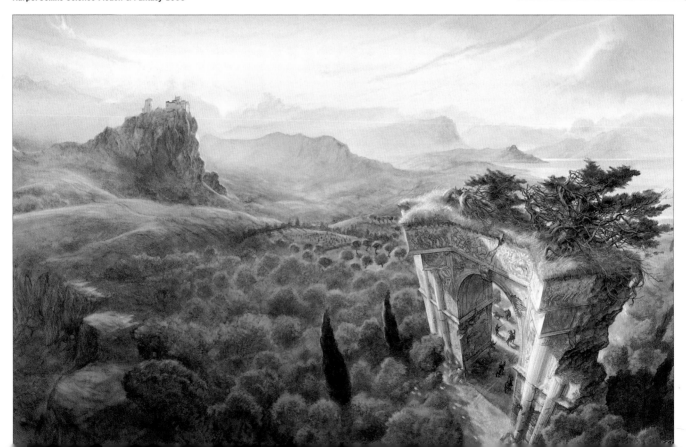

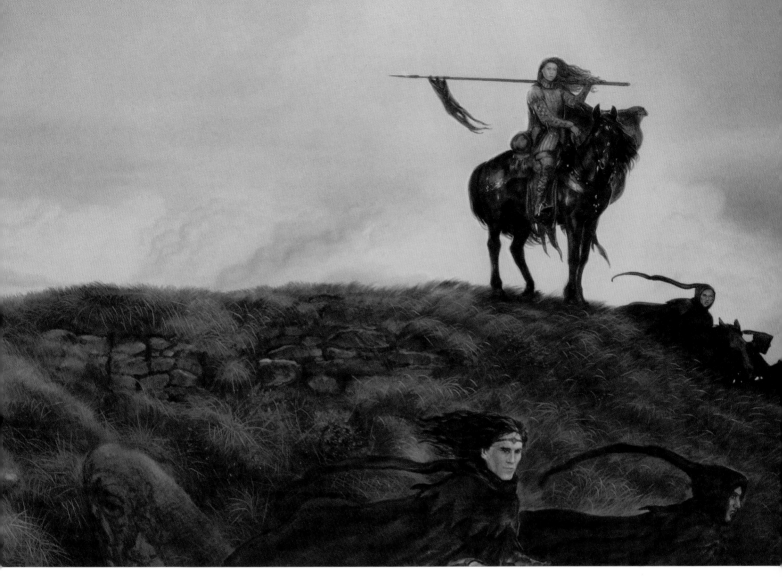

A Song for Arbonne (hardback) by Guy Gavriel Kay,
HarperCollins Science Fiction & Fantasy 1992

The Wanderer by Cherry Wilder,
Tor Books 2001

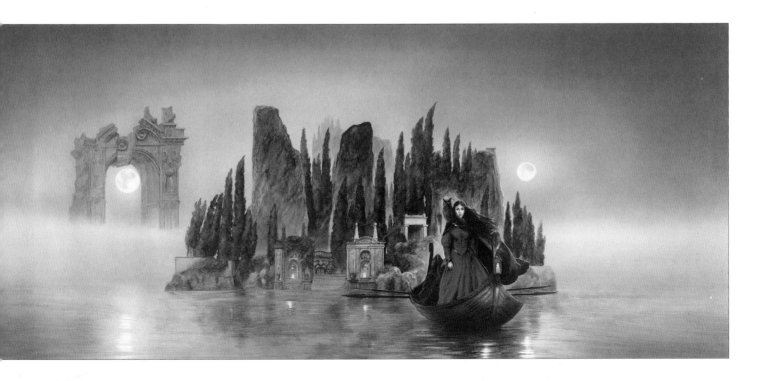

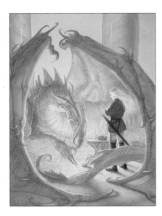

Left: The Cup of Morning
Shadows by Rosemary Edghill,
DAW Books 1995

Below left: The Sword of
Maiden's Tears by Rosemary
Edghill, DAW Books 1994

Below: Tower of the
King's Daughter by Chaz
Brenchley, Orbit 1998

Below : Born of Elven Blood by
Kevin J Anderson & John
Gregory Betancourt 1994

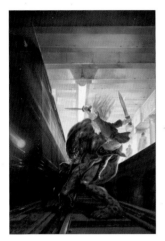

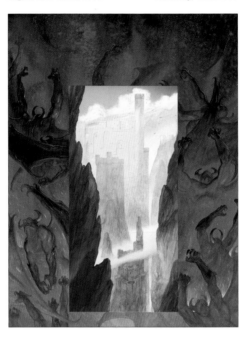

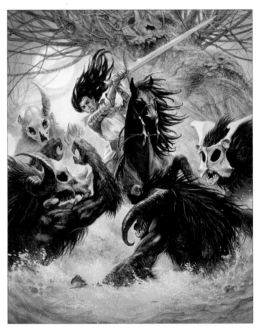

The Dragon-Charmer by Jan Siegel, HarperCollins Voyager 2000

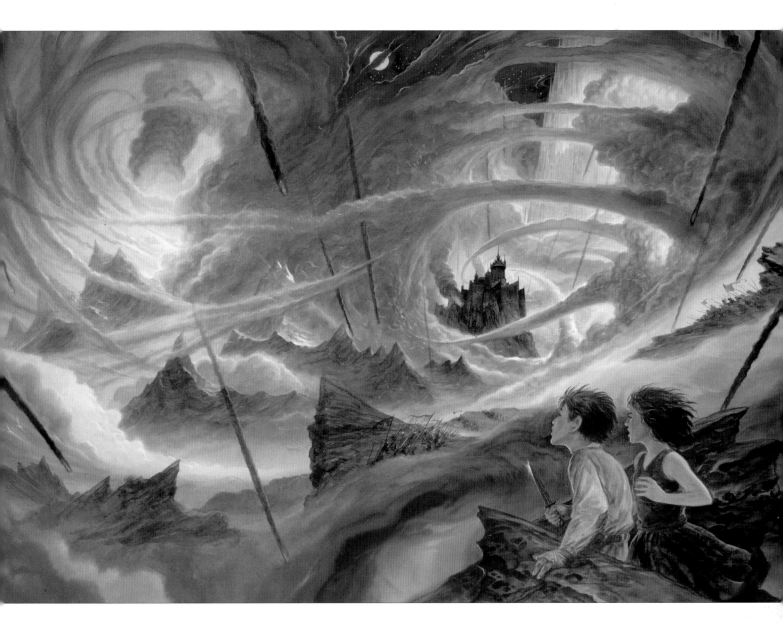

THE AMBER SPYGLASS

I was terribly excited to do a Phillip Pullman cover. The novels are eccentric, dark, at times grim, but incredibly visual, and the thought of dipping into such a universe, even with just one picture, had me reading and sketching half the night. I ended up submitting two covers for *The Amber Spyglass*, but in the end neither was retained and another artist was commissioned to paint a different scene. It doesn't happen often – only to the covers that I most desperately want to have work!

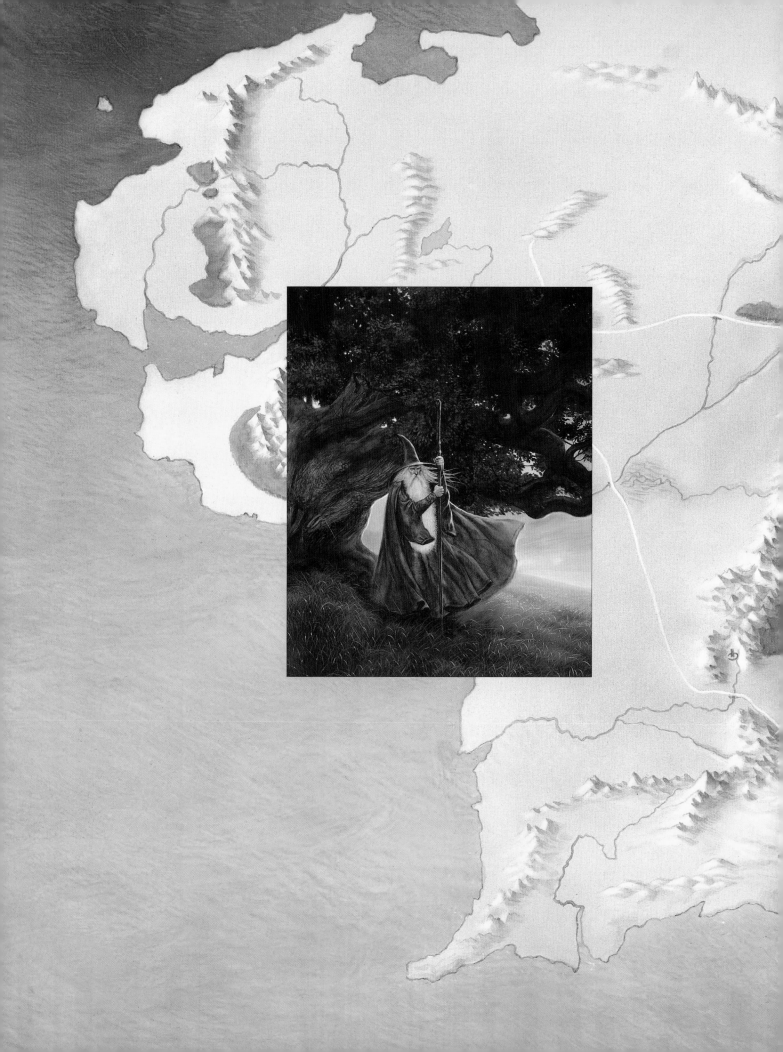

FROM HOBBITON TO MORDOR

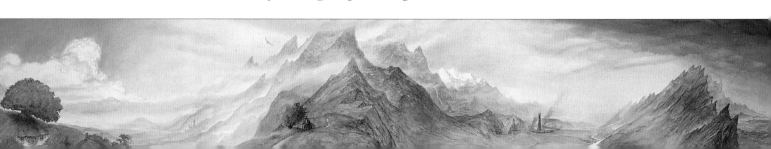

Previous: Gandalf, The Lord of the Rings board game,
Sophisticated Games/Parker Brothers 2000

Icy mist swirls between towering crags shrouded in blue-shadowed snow. The purple-tinted sky is illuminated with a sudden orange burst of flame erupting from a perilous peak. Describing this scene in *The Lord of the Rings*, J. R. R. Tolkien wrote: 'Those that looked up from afar thought that the mountain was crowned with storm.' In John Howe's depiction, 'Zirakzigil' [page 125] that seeming storm is very real and, at its heart - licked by tongues of fire, yet half-obscured by cloud and the shifting haziness of a great heat – two figures: a monstrous creature, its wings spread wide, its tail curled around the mountain top; and, silhouetted in the white-hot blaze that is the beast's breath, a man wielding a tiny sword that shimmers in the conflagration with a searing whiteness.

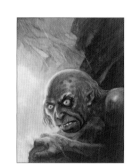

This is a classic John Howe illustration: a transitory moment, plucked from a dense, complex text and rendered into powerful, haunting imagery. He captures the restless sense of journeying that lies at the heart of the book. Houses, homes and halls, castles and palaces all have, however exotic and extraordinary their construction, a sense of place and permanence. Everywhere else, whether places of breathtaking beauty or fearful devastation, are wild, vast and daunting.

The pictorial journey begins, where the stories of *The Hobbit* and *The Lord of the Rings* begin: at Bag End [page 75], with its stools and settles, its carved wood and polished flag-stones and its round, fresh-painted front door standing wide open to the world beyond. From the safety and security of this most homely of home we look out, as did Bilbo and Frodo, to the road that goes ever on and on towards the distant misty hills of adventure.

Just as fantastic and yet equally as real is his vision of 'Edoras' [page 124] with the Golden Hall of Meduseld, seat of King Théoden, crowning a great green-gold fortified hill-top behind which looms the snow-swept splendour of the White Horn Mountains. Or, again, 'Minas Tirith' [page 128], the city of Gondor, with its seven-tiered defences, its citadel perched upon the sheer seven hundred foot high cliff-face, and the soaring finger of stone that is the great White Tower of Ecthelion.

At his most successful, John Howe counterpoints his landscape with the peoples who inhabit them: Gandalf [page 110] striding resolutely through a Middle-earth that is simultaneously sluiced with rain and bathed in sunlight; the Fellowship, dwarfed by great boulders of rock, as they climb Caradhras [page 116], while distant blizzards of snow are swept off the jagged mountain peaks beyond; two small hobbits

Top: Shire Vignette
The Map of Tolkien's Middle-earth
by Brian Sibley, HarperCollins 1997

Below: Middle-earth, The Lord of the Rings
board game, Sophisticated Games/Parker
Brothers 2000

watching from a high branches of a lichen-covered tree as a gigantic Mumak lurches through shafts of sunlight and careers across a stream towards the dappled shade of mossy woods [page 127]; or Sam and Frodo, concealed amongst a grim host of brutally armoured Orcs, making the terrible trek through the desolate wastes of Mordor with its grey storm skies and ashen crags [page 132].

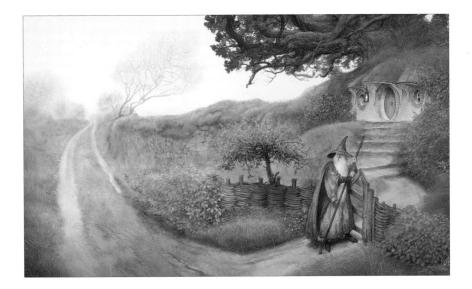

Gandalf Returns to Bag End
The Return of the Shadow by Christopher Tolkien, Grafton 1994

Some his most powerful pictures are those depicting the struggle between the forces of good and evil. In the heat of battle on the Pelennor Fields, Éowyn - clad in virgin white - wields her sword against her fearful adversary, the Witch-king of Angmar [page 129]: two burning eyes within the blackness of his crowned helmet, his Nazgûl-steed a nightmare of wings, scales, claws and teeth. Elsewhere, in the cold blue passageways of death in Shelob's Lair [page 4], beneath the Mountains of Shadow, Sam, ducks beneath the arching spider-limbs and lunges at the creature's hideous bulk with the sword Sting, a searing shard of light.

Or, take the terrible climax to Gandalf's battle with the Balrog [page 120], as the monstrous creature plunges downwards into the depths of Moria, its taloned beast-hands spread, the great red maw of its mouth opened in a roar of rage, its vast bat-wings folded in and made transparent by the burning light of Gandalf's sword, raised above his head as - his silver beard blown back, his arms and legs bloodied from the struggle - he clutches the brute by its throat and falls, along with his foe, towards the abyss and doom.

Above all, John Howe's consummate skill is in bringing realism to the picturing of the fantastic: characters, landscapes and moments of conflict, triumph and disaster.

Brian Sibley

Opposite: Gollum vignette
The Map of Tolkien's Middle-earth by
Brian Sibley, HarperCollins 1997

Black Riders in the Shire Tolkien
Calendar 2001, HarperCollins 1999

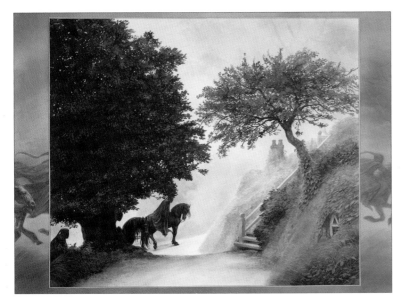

GANDALF THE GREY

Preparing to play Gandalf onscreen was initially no more troubling than getting to know any other character well enough to impersonate him. I had not read *The Lord of the Rings* and when friends cautioned that millions who had would be waiting to pounce if I contradicted their own image of the Wizard, I was comforted by my experience of playing many classic parts already achieved and embodied by generations of actors. But, no one else had yet played Gandalf on screen and his adventures were the most popular fiction of my lifetime. Then, meeting the legion of insistent fans via the internet, I became less complacent.

In October 1999 I met the artistic team for the films in New Zealand and in the Wellington workshops sat through two days of make-up tests and costume fittings. I didn't know quite what to expect but they were all clear enough – they consulted Tolkien's descriptions and they propped John Howe's illustration of Gandalf the Grey by the mirror. The author and his acclaimed illustrator were their guides and only when I looked like the John Howe's Gandalf, were they satisfied that I could start to play Tolkien's.

They were right.

Sir Ian McKellen

Gandalf the Grey
The Lord of the Rings one-volume edition
by J R R Tolkien, HarperCollins 1989

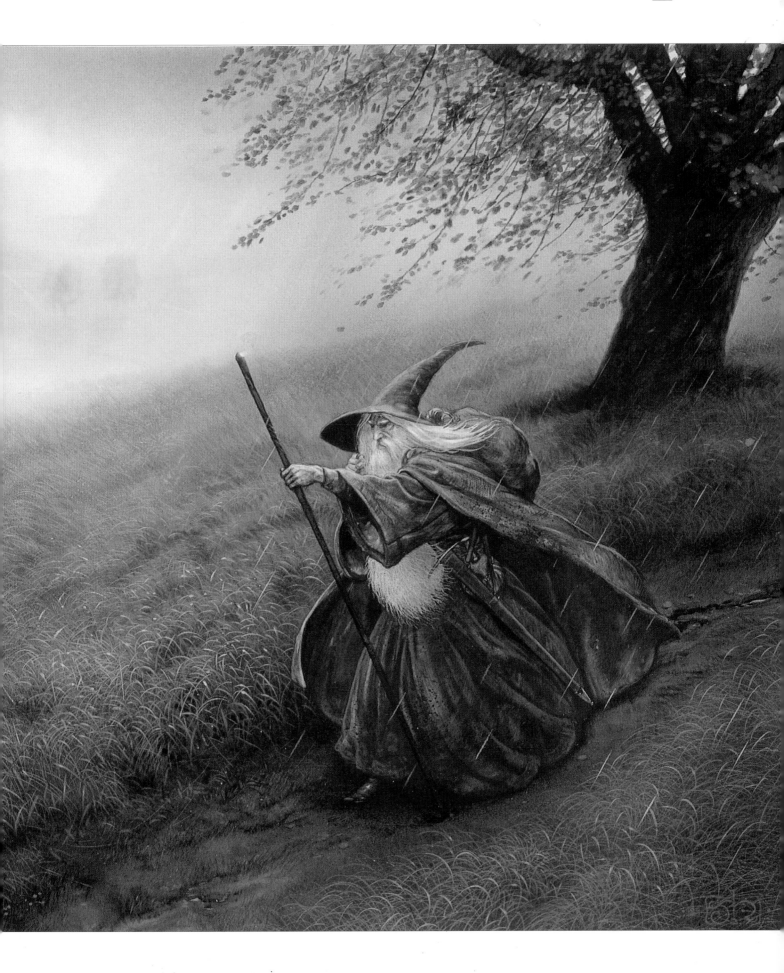

EARLY TOLKIEN

All my early work based on *The Lord of the Rings* seems to focus on the action scenes, usually involving Mordor's servants. All heavily heroic fantasy, with lots of horned helmets, morningstars and various spiky bits. Any appreciation of the deeper aspects of the stories was to come later.

'Grond' [pages 6/7] was a pure pretext to depict fire and smoke and unusual creatures, passed off as a school project. I can't for the life of me remember what marks I was given on this! On the other hand, visions are persistent, and I find that many of my very early – and often erroneous – impressions from Tolkien have stayed with me tenaciously through the years.

'The Black Rider' [page 112] is a perfect example. I owe the image to the Ralph Bakshi animated film – in the book the Rider never approaches quite so closely – and to a hike on the West Coast of Vancouver Island. It's rare to find a bit of landscape that meshes so exactly with a picture in your head. So in the end, all that had to be done was tuck the hobbits under the roots and place the Rider behind.

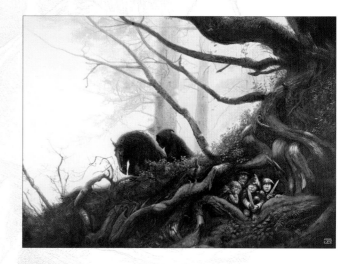

The Black Rider
Tolkien Calendar 1987,
HarperCollins 1983

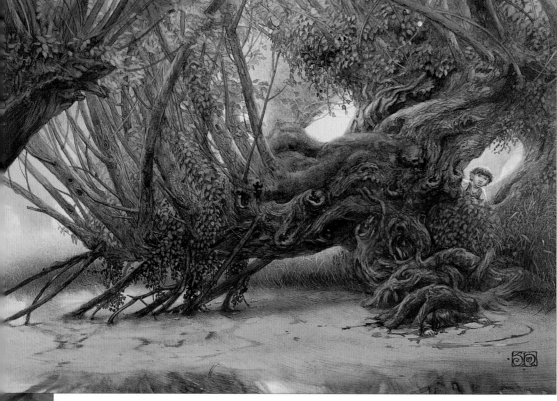

Old Man Willow
Tolkien Calendar 1991,
HarperCollins 1989

Old Man Willow pencil
sketch 1989

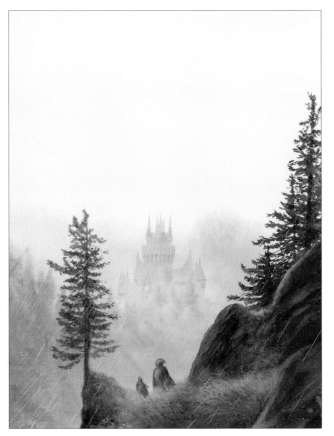

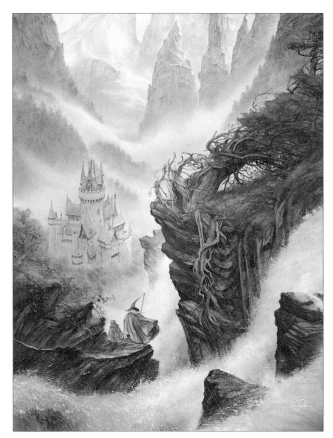

Descent to Rivendell
The Map of Tolkien's Middle-earth
by Brian Sibley, HarperCollins 1997

Rivendell
The Fellowship of the Ring by J R R
Tolkien, HarperCollins 1990

At the Ford
Tolkien Calendar 1991,
HarperCollins 1989

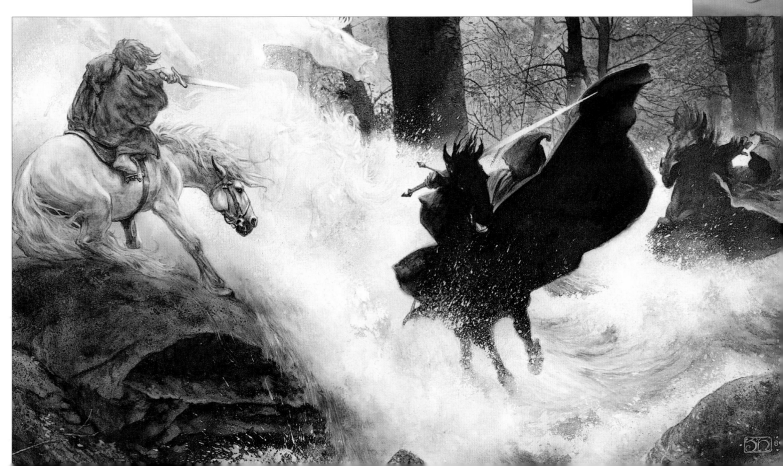

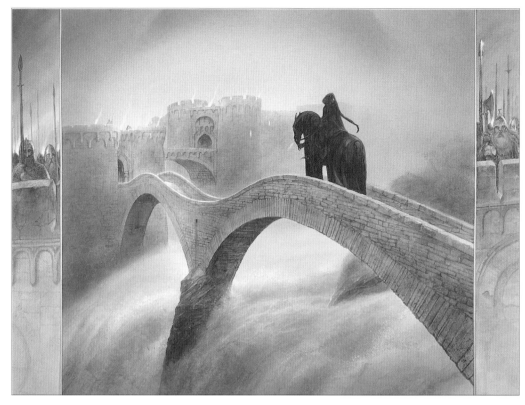

Gandalf Enters Dol Guldur
Iron Crown Enterprises 1997

Horseman in the Night
Tolkien Calendar 2001,
HarperCollins 1999

Opposite:
Gollum Flees the Elves of Mirkwood
Tolkien Calendar 2001,
HarperCollins 1999

Escape from Orthanc
Tolkien Calendar 2001,
HarperCollins 1999

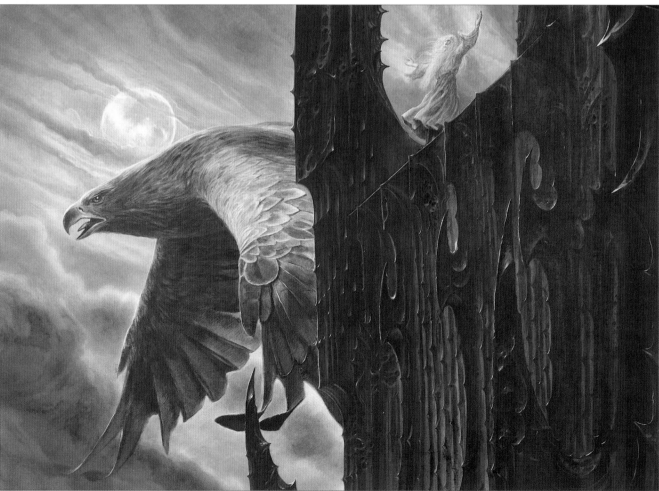

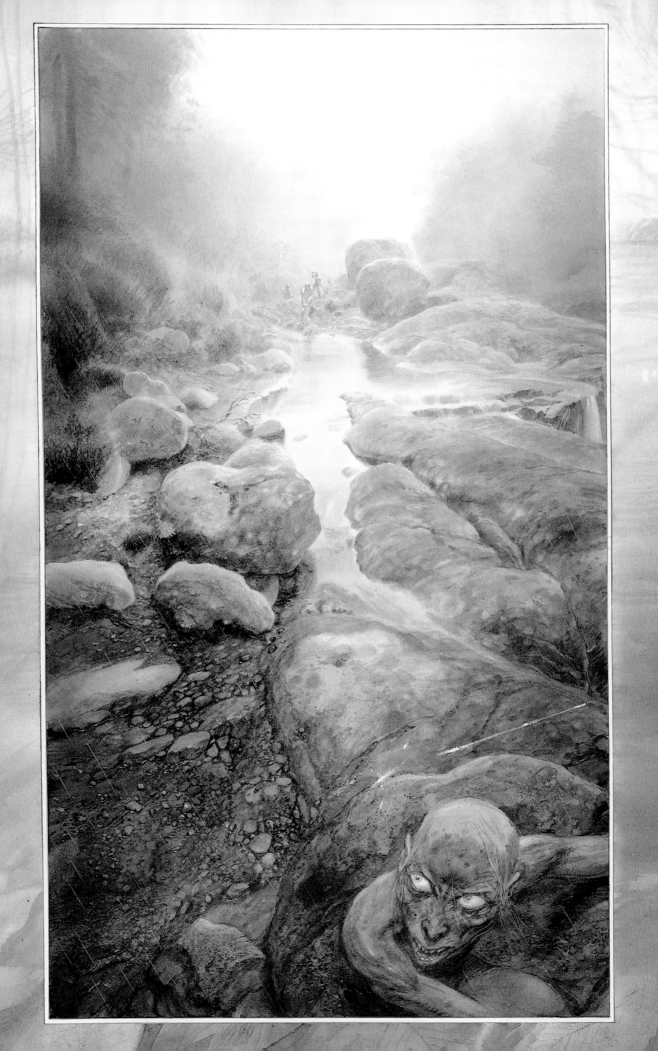

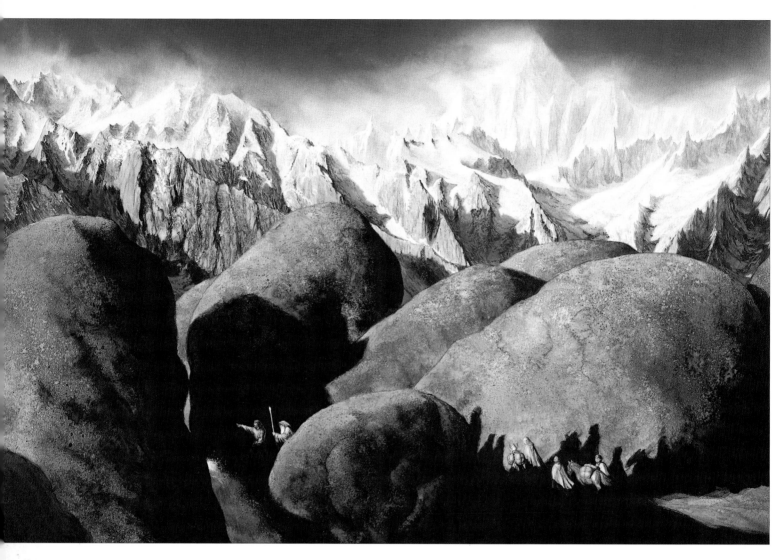

Road to Caradhras
Tolkien Calendar 1991,
HarperCollins 1990

Opposite top left: Arwen
The Lord of the Rings board
game, Sophisticated
Games/Parker Brothers 2000

The Watcher in the Water
Iron Crown Enterprises 1997

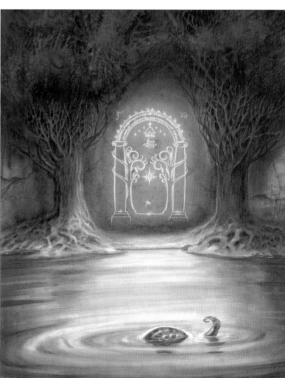

Moria Gate watercolour
Tolkien Enterprises

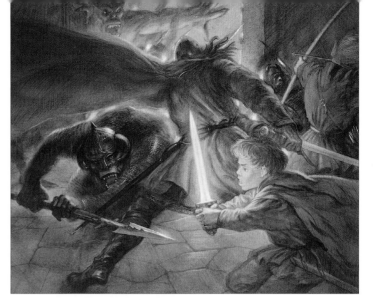

Under his Blow
Iron Crown Enterprises 1997

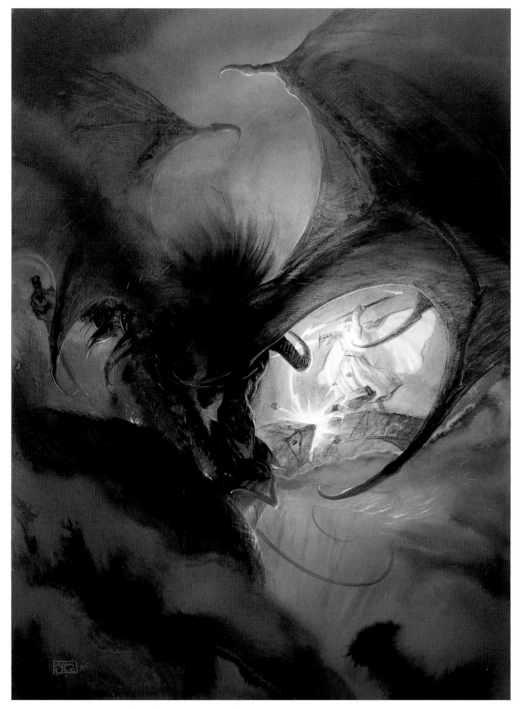

Bridge of Khazad-dûm
Tolkien Calendar 2001,
HarperCollins 1996

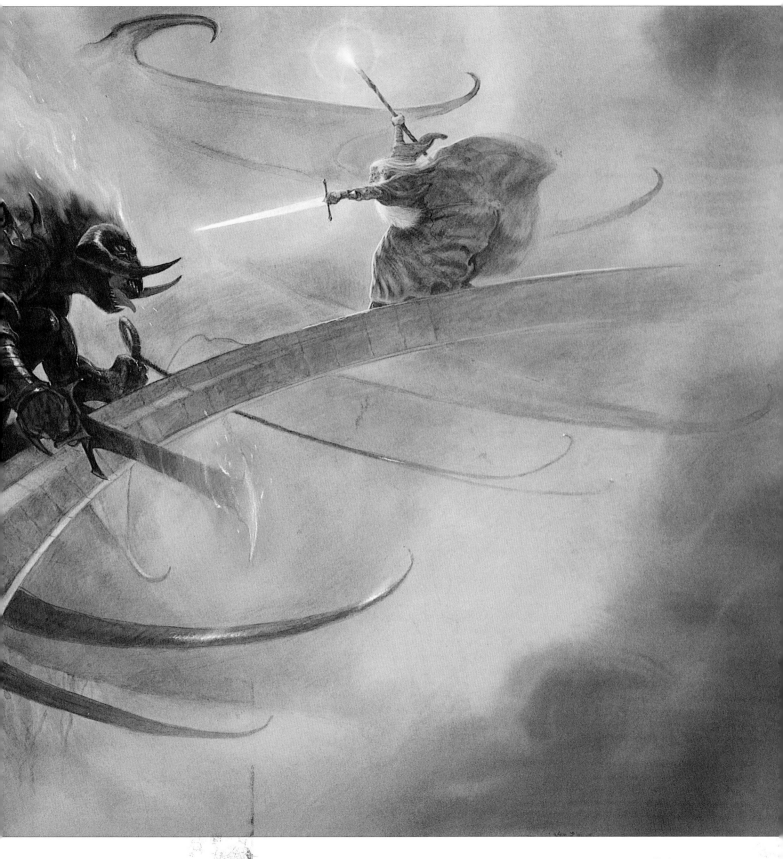

Moria
The Lord of the Rings board game,
Sophisticated Games/Parker Brothers 2000

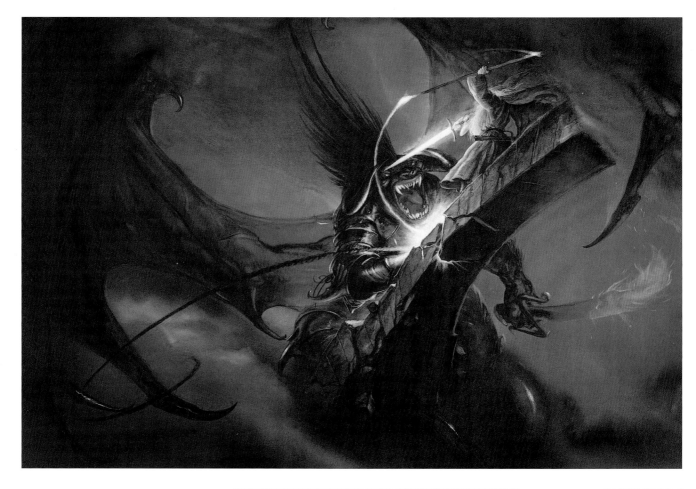

Gandalf & the Balrog
Realms of Tolkien,
HarperCollins 1996

Opposite: The Argonath
Tolkien Calendar 2001,
HarperCollins 1999

Gandalf Falls with the Balrog
Iron Crown Enterprises 1997

Galadriel
Realms of Tolkien,
HarperCollins 1990

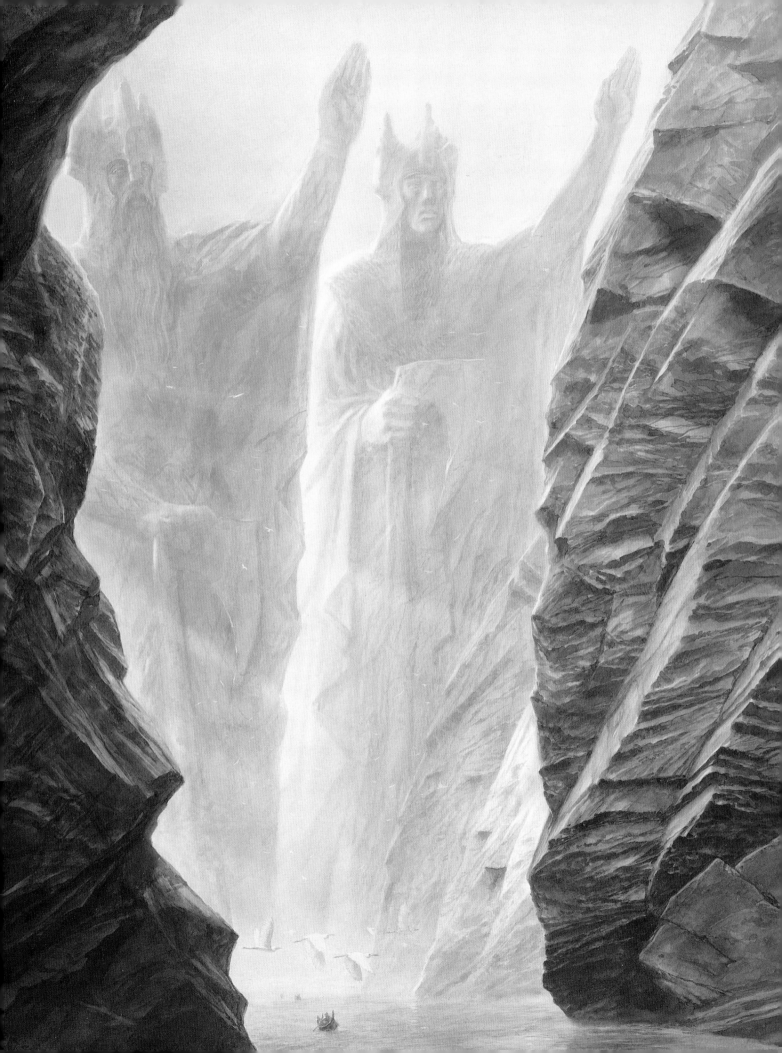

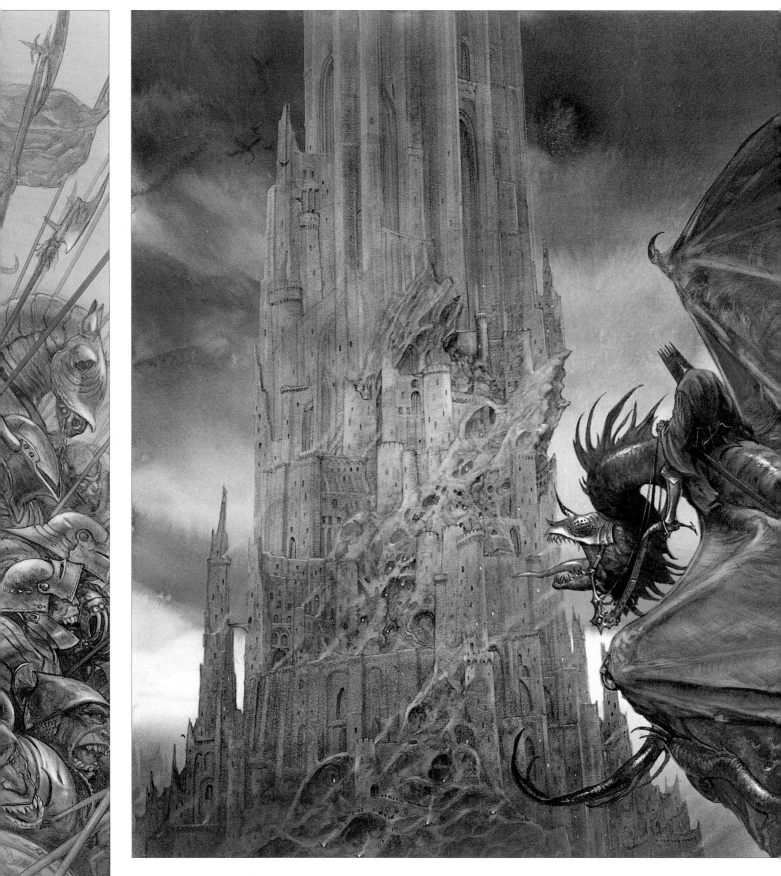

The Dark Tower, The Two Towers by
J R R Tolkien, HarperCollins 1989

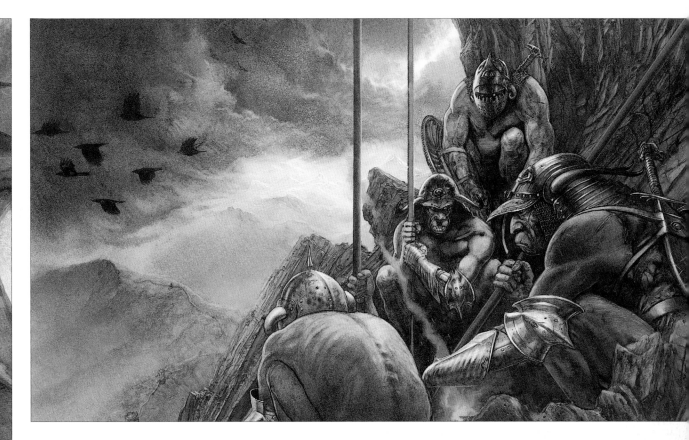

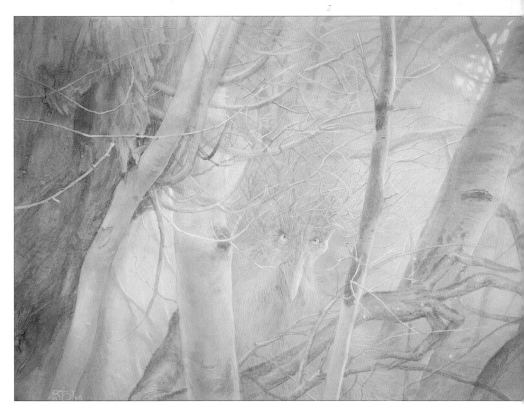

Below: The Nameless Isle, from The Dreamquest of
Unknown Kadath by H P Lovecraft, unpublished 1979

Above: Uruk-hai, Tolkien Calendar
1987, HarperCollins 1985

Above right: Treebeard,
Tolkien Calendar 1997, HarperCollins

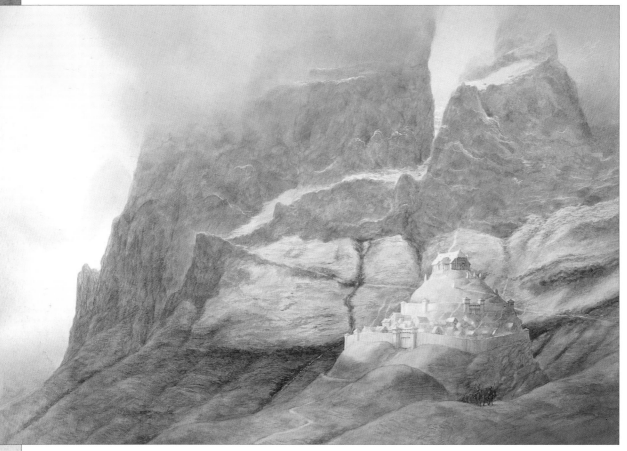

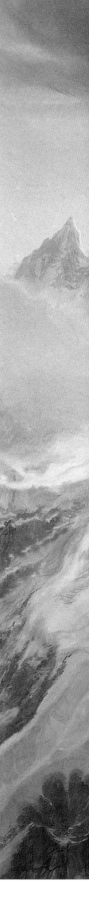

Edoras
The Treason of Isengard by Christopher Tolkien,
Grafton 1995

Opposite: Zirakzigil
Tolkien Calendar 2001,
HarperCollins 1999

Theoden
The Lord of the Rings board
game, Sophisticated
Games/Parker Brothers 2000

Arwen
The Lord of the Rings board game, Sophisticated
Games/Parker Brothers 2000

Boromir
The Lord of the Rings board
game, Sophisticated
Games/Parker Brothers 2000

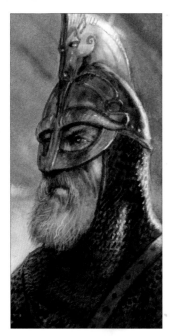

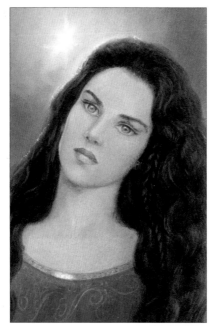

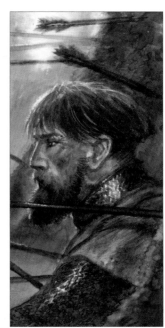

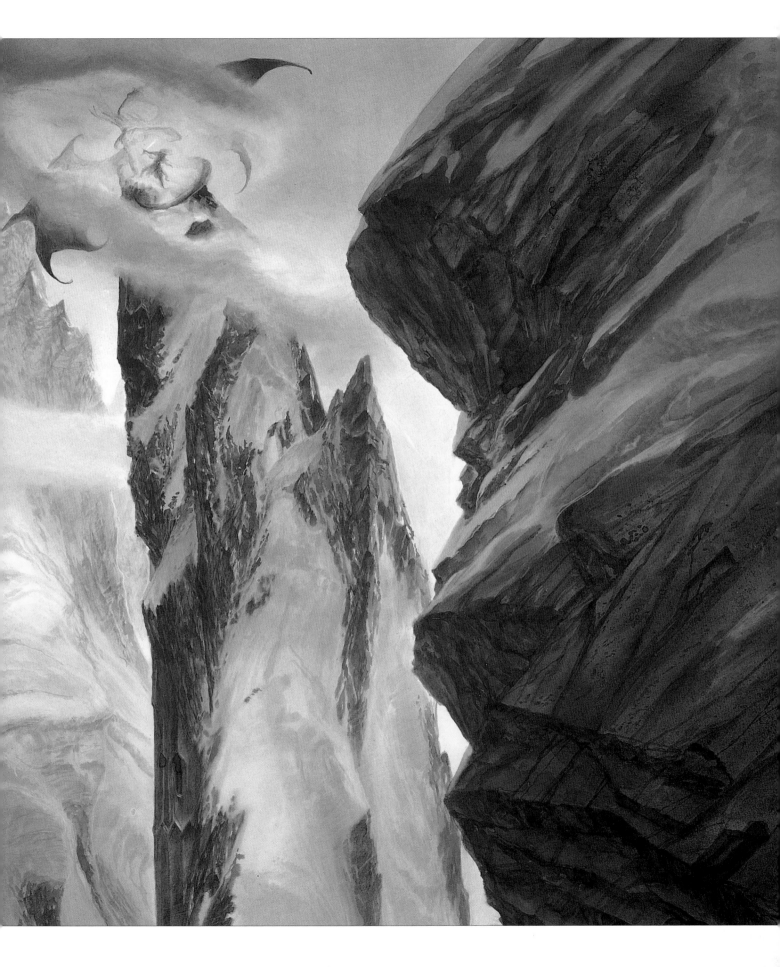

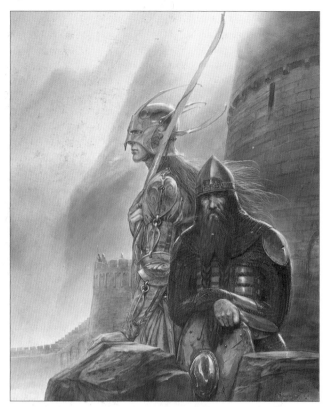

Legolas and Gimli
Tolkien Calendar 2001, HarperCollins 1999

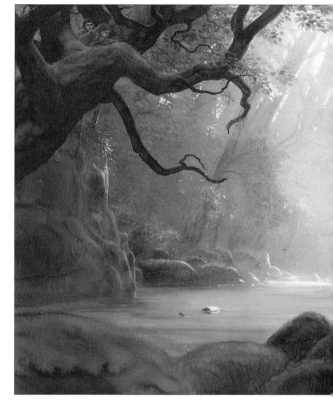

Below: Helm's Deep
The Lord of the Rings board game, Sophisticated Games/Parker Brothers 2000

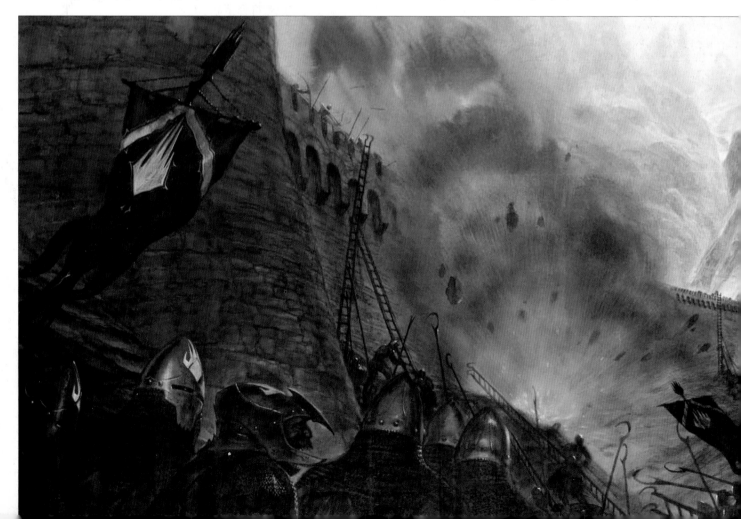

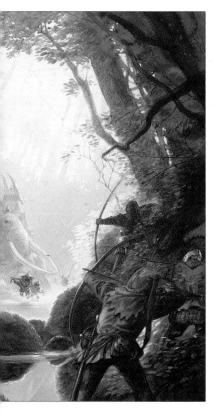

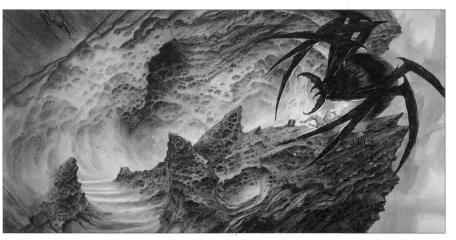

Shelob's Lair
The Lord of the Rings board game,
Sophisticated Games, Parker Brothers 2000

Shelob about to leap on Frodo
Tolkien Calendar 2001,
HarperCollins 1999

Above: Mumak of Harad
The War of the Ring by Christopher Tolkien, Grafton 1996

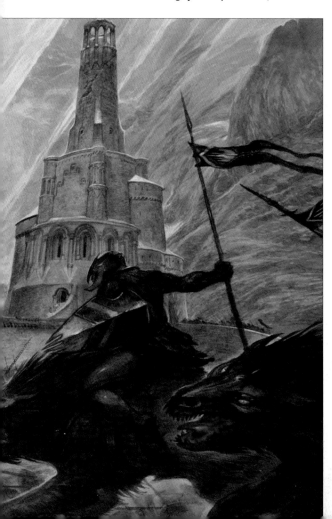

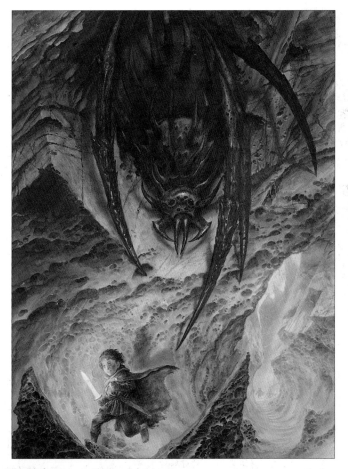

Gandalf approaches the Guarded City
The Complete Guide to Middle-earth
by Robert Foster, Grafton 1992

Right: Gandalf before Minas Tirith vignette
The Map of Tolkien's Middle-earth by Brian
Sibley, HarperCollins 1997

Minas Tirith
Tolkien Calendar 1991, HarperCollins 1990

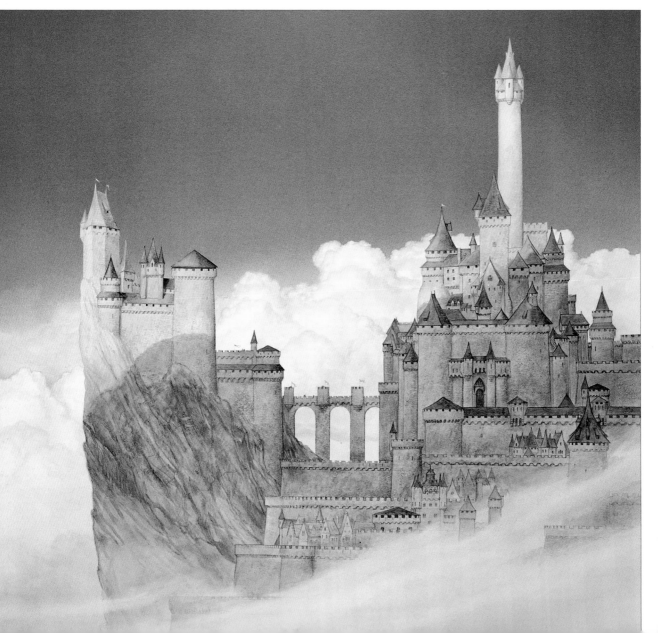

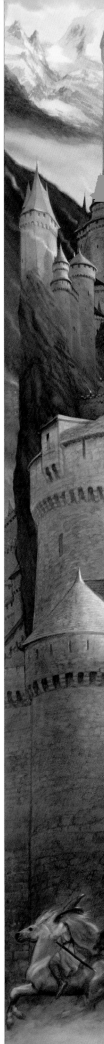

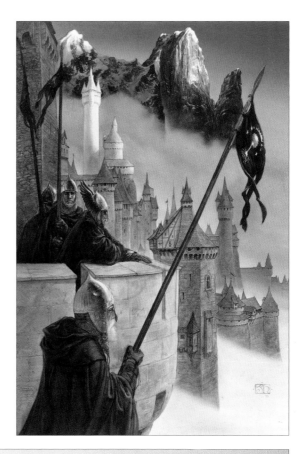

Minas Tirith
The Return of the King by J R R
Tolkien, HarperCollins 1990

Éowyn & the Nazgûl
Tolkien Calendar 1991,
HarperCollins 1990

Far right: Dark Tower vignette
The Map of Tolkien's Middle-earth
by Brian Sibley, HarperCollins 1997

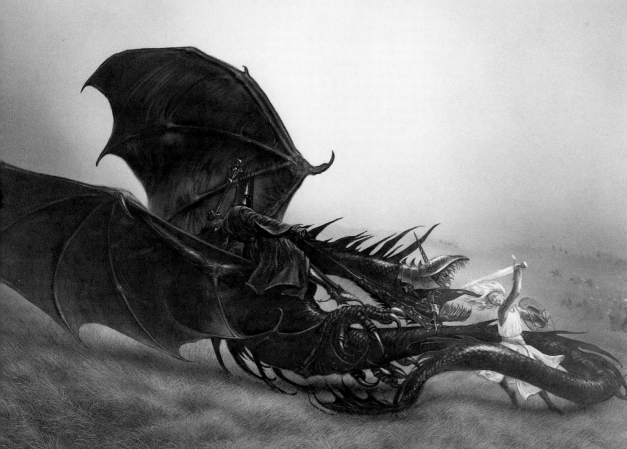

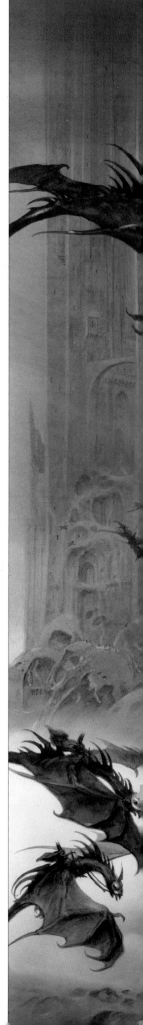

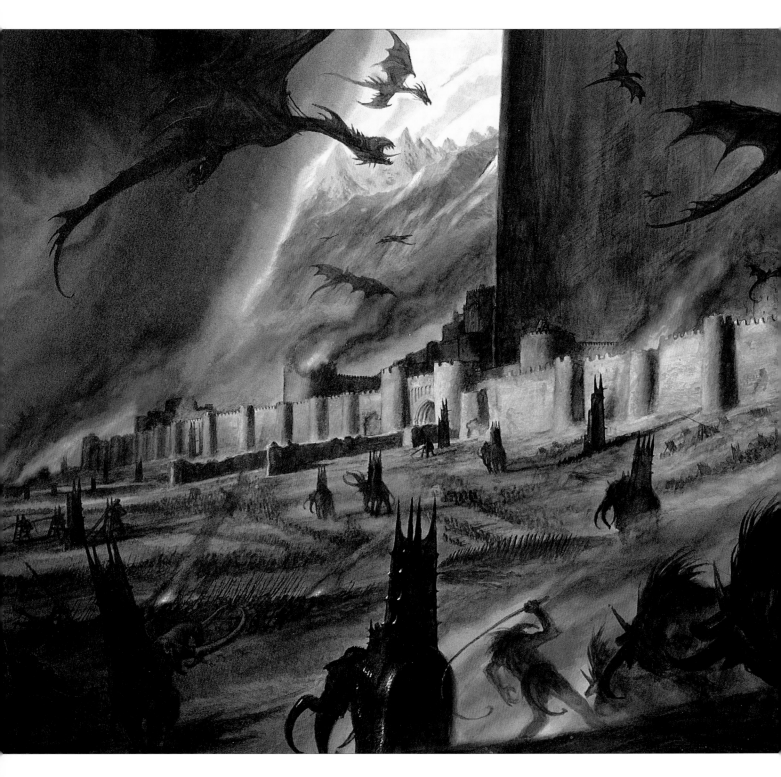

THE SIEGE OF GONDOR

I've spent years travelling towards Gondor. The first depictions of Minas Tirith are how I imagined it without ever really seeing it. Initially, I had imagined it as a grimmer, more northern place, with architecture closer to the Baltic than the Mediterranean. I hope subsequent glimpses are

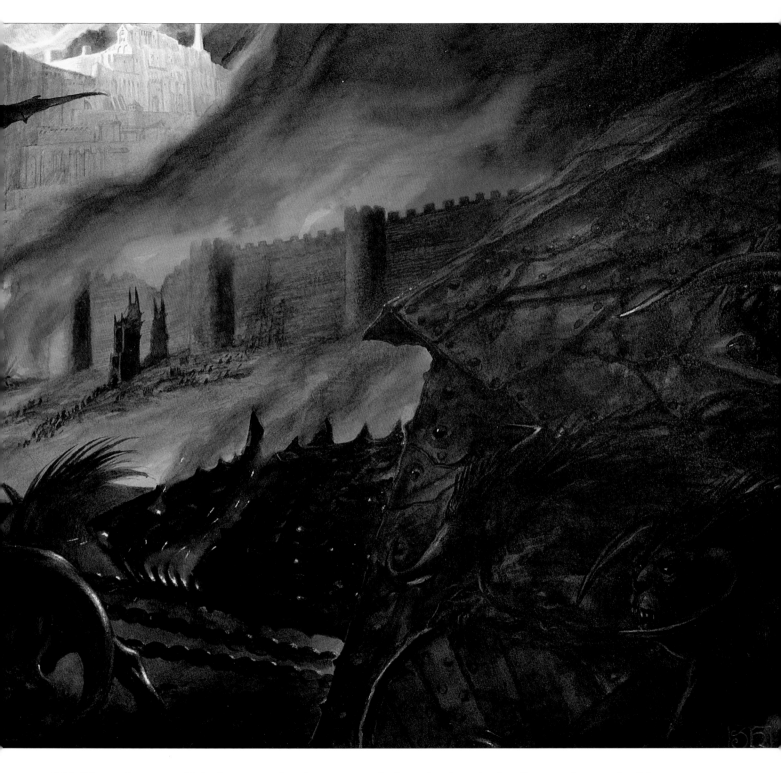

more faithful to the text. (I had even missed – along with everybody else, it seems - the fact that the outermost wall, built by the Númenóreans, is of black stone.)

I detest design-driven cities, all symmetry and smoothness. They are fine for science fiction, but a real city takes hundreds of generations to build.

So, I have finally made it to the Pelennor Fields, where I can get a proper view, but it seems there's a war going on…

The Siege of Gondor
Tolkien Calendar 2001, HarperCollins 1999

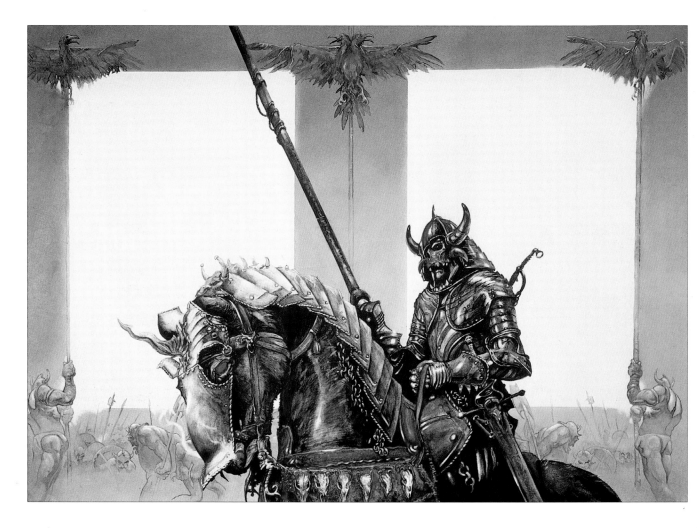

The Lieutenant of the Black Tower
Tolkien Calendar 1987, HarperCollins 1979

In Mordor
Tolkien's World, HarperCollins
1989

In Mordor pencil sketch
1989

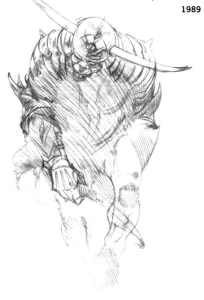

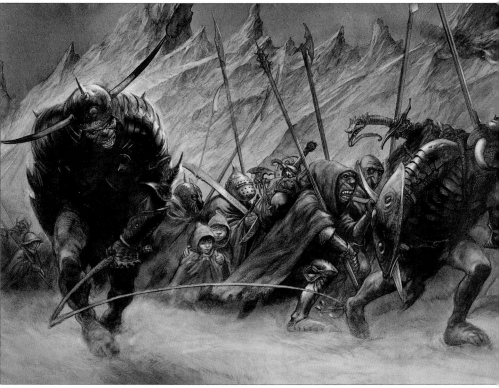

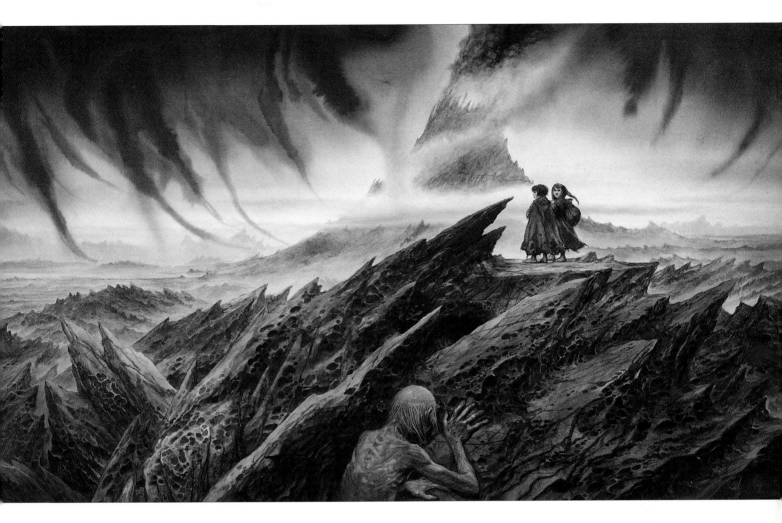

Mordor
The Lord of the Rings board game,
Sophisticated Games/Parker Brothers
2000

Mount Doom
(detail) Die Suche

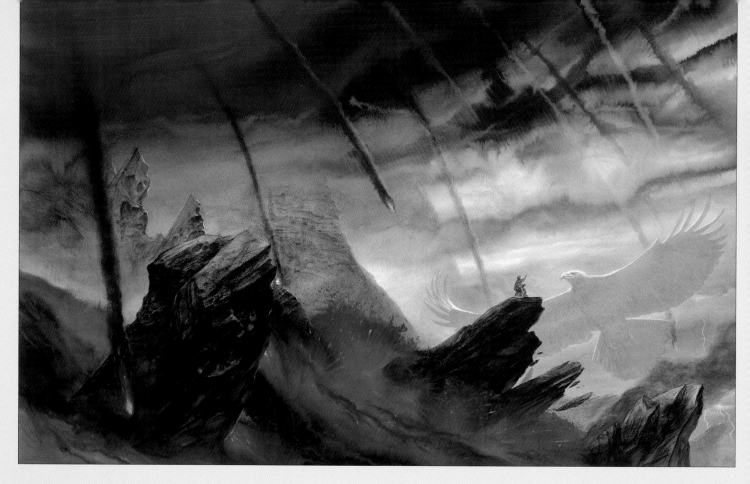

The Grey Havens Tolkien Calendar 2001, HarperCollins 1999

The End of the Third Age, The End of the Third Age by Christopher Tolkien, HarperCollins 1999

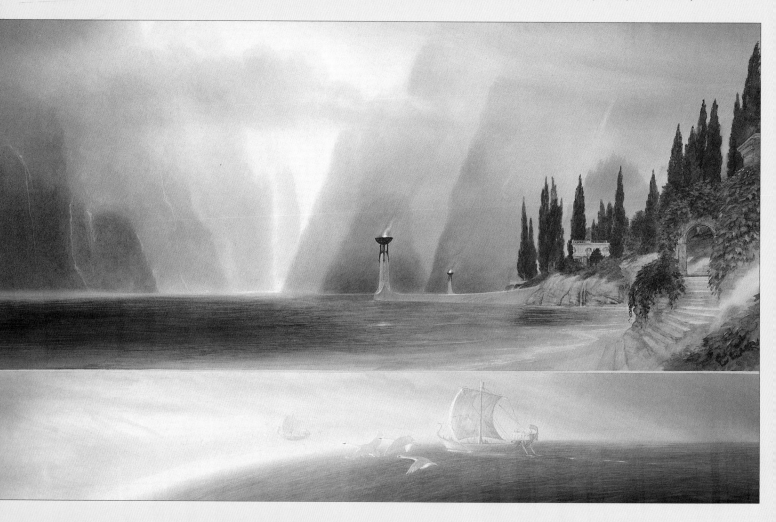

FRODO FACES THE RINGWRAITH ON AMON HEN

The scene that never was. The first script of *The Lord of the Rings* contained a scene involving a close encounter between Frodo and the Witch King on Amon Hen. It was subsequently abandoned, but in the meantime… Rumpled scruples accompanied this picture; it is difficult to compose with images that digress, or worse, open the Pandora's Box of "What if…?".

The Seeing Seat is just the tip of a huge design iceberg, including an abandoned fortress, with stairs and terraces stretching a good way back down to Parth Galen. During the design process, the urge to wander off, from Amon Hen to Amon Lhaw, around the shores of Nen Hithoel, sketching on the way, was very hard indeed to resist.

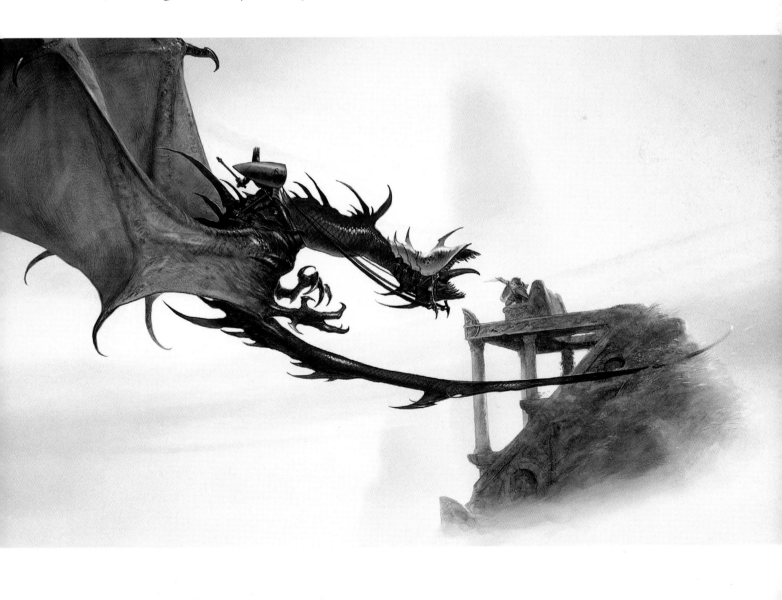

Fifteenth-century Italian armour. The real thing, for once! Surprisingly comfortable, though the gentleman it once belonged to had a slimmer waist than I, and legs twice as thick. Must come from spending your life on horseback and not in front of a drawing table.

CHAPTER SEVEN

GETTING IT RIGHT

Special thanks to the Companie of Saynt George

Bestowing a level of integrity on any fantasy world means accepting aspects of it that you may never explore, constructing an alternative art history, creating artefacts and costume styles, accepting inconsistencies and blank spots, finding the best way to make it appear as a realistic universe. Something of a contradiction, perhaps, but the necessarily empirical approach involved – if indeed you are provided with the excuse to return to any given world – weaves these inconsistencies into the fabric of the place. It all comes down to 'getting it right'.

But how do you make a cloak look convincing? When is a sword blade too long or too wide? How is the grip constructed? How do helmets stay on heads?

Between the neighbour in a sheet secured with a safety pin and a character wearing half a dozen square metres of natural wool sewn into a proper

Boar hunting. And no, we didn't do it for real. Those things are dangerous.

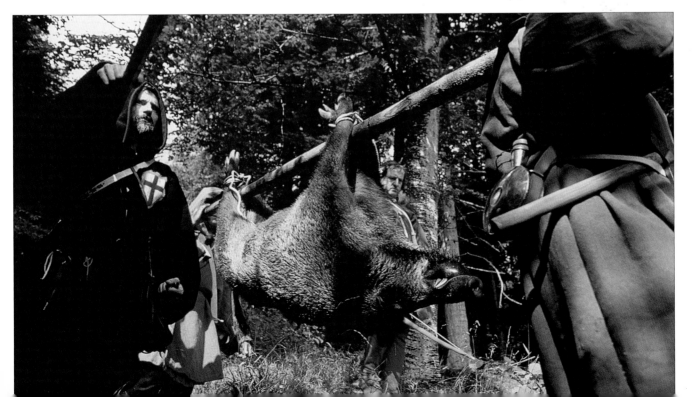

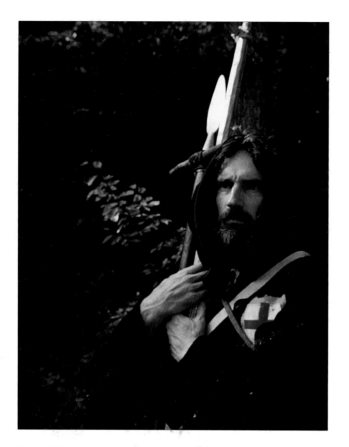

Fourteenth-century archer. The bow pulls at 140 pounds, but at least I can pretend to string it.

Opposite: Soldier from Canton Uri. The cloth jack took weeks to make.

cloak and fastened accordingly, there is a huge difference, and probably more of it sneaks into a picture than you would think. So, how do you draw a proper sword? Once again, the willing neighbour holding the yardstick is fine, but it's still second best.

The real answers to these questions are to be found in archaeology, and then getting your hands on it. Of course, you can't (always) pick up museum exhibits and you certainly must not wave them about, but a conscientious reconstruction of an object, one that you can use, abuse and repair, wear and carry around, can be exceedingly instructive.

If it can't be real, it should be realistic. This is hardly the place to discuss the relative merits of historical re-enactment, but the principal aims of serious living history are just that, trying to 'get it right', with the full awareness that 'right' one month may be considerably modified by new research and finds the next. While it is an exercise in applied

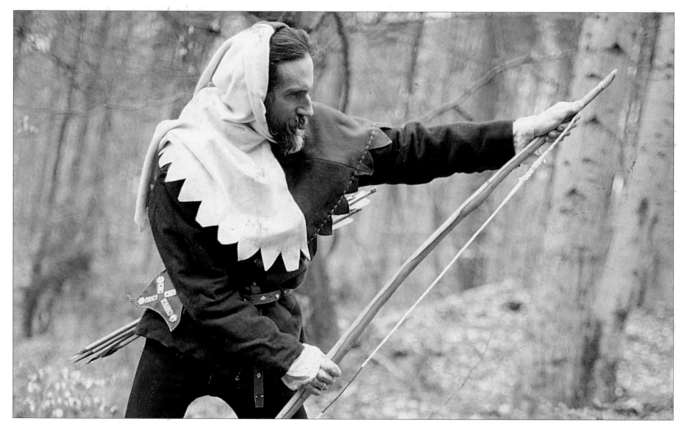

imperfection, the path followed by like-minded individuals is in their forays into history. This is an exceptionally useful one for the artist. There is so much to see along the way.

As they no longer exist, nearly all of the items used in living history must be recreated, thus I find enormous satisfaction in making objects. It seems so much more concrete than pushing colours around on a flat piece of paper, and it must be therapeutic in some way; I try to do as much of this as I can. More importantly, the nature of the materials used will lead the hand and mind to designs inaccessible to a pencil on paper.

Our garage and attic are consequently piled high with shields of every period, with lances, spears and bits of armour, old tools, tree roots – all the flotsam and jetsam of sudden inspiration, which usually rises quickly and then slowly ebbs, leaving dozens of half-finished artefacts above the tide line. Gandalf wears a sword I own, the giant in Jack and the Beanstalk a costume belonging to a friend, Lancelot's armour (page 44) is in another friend's attic. While they may end up gathering dust, they are often propping up some notion of reality somewhere in a painting.

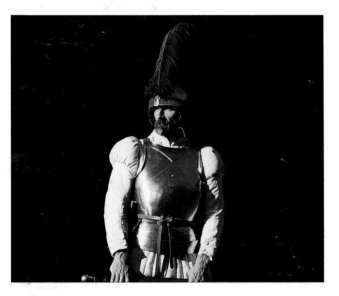

After one very hot afternoon of photos. The mail shirt is for real and the swords sharp. Trying to choreograph fake fight scenes with sharp weapons is an exercise in restraint.

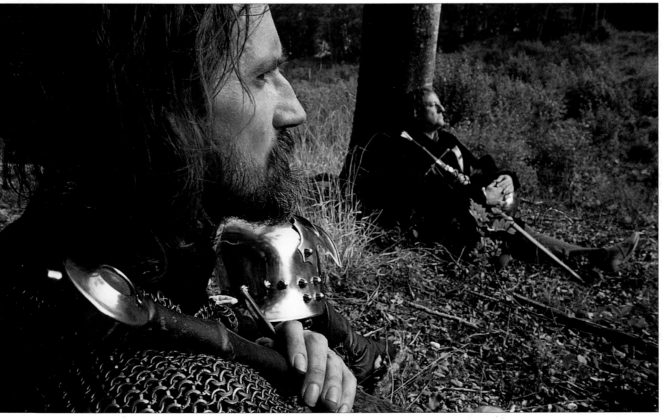

AFTERWORD

I first met John on a Singapore Airlines flight to New Zealand in January 1998. We talked about our approaches to illustrating Tolkien, and John spoke passionately of the need to construct fantasy on a bedrock of authenticity.

He also mentioned that he'd brought along a few items from his own collection of medieval artefacts and re-creations to serve as inspiration and reference. I waited for him at Auckland airport and he eventually emerged with his trolley piled high with boxes containing his shields, swords, and armour, and carrying his longbow over his shoulder. 'But John, where's your suitcase?' I asked. We peered back through the gateway and could see it sitting forlornly in the Customs hall, but there was a 'No Entry' sign and a large man resembling a Royal Canadian Mounted Policeman between us and it. It took John another half hour to negotiate the retrieval of the sinister-looking object while I guarded his arsenal of medieval weaponry, and we made the flight to Wellington with minutes to spare.

So began our friendship and our part of the adventure of creating the look of Middle-earth for Peter Jackson's film trilogy of *The Lord of the Rings*. We shared a studio at Weta working alongside Richard Taylor's designers on creatures, armour and weaponry, and on the long list of miniatures which were to be created for the films. There was a lot of consultation between us and Richard and Grant Major, the Production Designer, and of course with Peter, who was always encouraging us to take a fresh look at things we'd each drawn many times before. Our labours seemed to divide up quite naturally, with John concentrating on the darker aspects of Middle-earth – Fell beasts, the Balrog, Barad-dûr, Minas Morgul and the Black Gates etc, while I kept mainly to the safer side of the Anduin. There were exceptions though and John's designs for the Bucklebury Ferry, the Green Dragon Inn and the beautifully detailed Bag End set would please even the most discerning of Hobbits.

John is highly productive, producing brilliant drawings in the brief periods when his turbo-charged metabolism allows him to sit still – then running off to the Weta armoury and returning half an hour later with a handful of Orcish arrowheads that he'd just forged. This energy can be traced in many of his drawings, where a Gollum, or a Ringwraith, a hilt for one of the many beautiful swords he designed, and a conceptual

design for Shelob's Lair, for example, fight each other for space on the same sheet of paper. Afternoons were punctuated by the occasional clash of arms as impromptu duels between John and the armourers were fought in the Weta forecourt.

John's knowledge of the medieval world was an inspiration for all of us working alongside him, and his passion for authenticity in weapons, armour and fighting styles, forged from his experience as an illustrator and his long-term involvement in medieval re-enactment, will be reflected in many of the more dramatic scenes in the films.

His paintings always grasp as the most vivid moments. The detail and scope of his imagery is always impressive, always lifting the viewer's gaze to new heights. He is a true Gothicist in his art, and in the liveliness of his mind, his insatiable curiosity and in his genuine love for the values of chivalry as well as its trappings.

I think John would have been perfectly happy as a medieval scribe, covering the borders of his manuscripts with a wilderness of vibrant designs, or as a craftsman working high up on a cathedral tower creating an endless tracery of creatures and characters but, fortunately for us, his work is reaching a wider public through his books and film designs.

His love and respect for Tolkien's world is apparent through the imaginative power of his illustrations and the integrity he brings to all aspects of his design work. Large tracts of Middle-earth are brooded over by John's awe-inspiring structures. His Barad-dûr, glimpsed through clouds of swirling vapour, will be an enduring image in many minds, as will his Gandalf striding purposefully through the Shire.

That image, and a few treasured photos will remind me of one of the most pleasant facets of our experience in New Zealand: exploring its hills, forests and mountains looking at possible locations. I got fairly fit trying to keep up with Peter Jackson but John seemed to be everywhere at once – a tiny silhouette standing on a crag to the left, then a determined figure marching across a hillside to the right, flocks of sheep scattering before him like Orcs before Anduril. He absorbed his experience here with a gusto that I sat back and marvelled at. I look forward to seeing how it manifests itself in his subsequent work.

Alan Lee